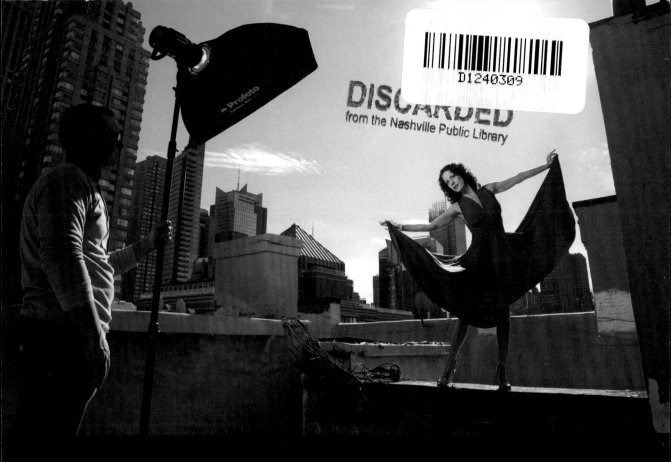

Lighting & Design

for PORTRAIT PHOTOGRAPHY

Direction & Quality of Light

Neil van Niekerk

AMHERST MEDIA, INC. ■ BUFFALO, NY

About the Author

Neil van Niekerk, based in New Jersey, specializes in portrait, wedding, and boudoir photography. He also maintains Tangents (www.neilvn.com/tangents), an active web site for photographers. He teaches workshops and seminars on photography, and has written three other popular books on lighting for photography, which have been translated into Polish, Portuguese, and Chinese. Originally from South Africa, Neil worked as a television broadcast engineer there until 2000, when he emigrated with his family to the United States. He has pursued photography as a full-time career ever since.

To see more of Neil van Niekerk's work, visit:
www.neilvn.com/tangents
www.oneperfectmoment.com
www.facebook.com/neilvn.photography

Copyright © 2015 by Neil van Niekerk.
All rights reserved.
All photographs by the author.

Published by:
Amherst Media, Inc.
P.O. Box 586
Buffalo, N.Y. 14226
Fax: 716-874-4508
www.AmherstMedia.com

Publisher: Craig Alesse
Senior Editor/Production Manager: Michelle Perkins
Editors: Barbara A. Lynch-Johnt, Harvey Goldstein, Beth Alesse
Associate Publisher: Kate Neaverth
Editorial Assistance from: Carey A. Miller, Sally Jarzab, John S. Loder
Business Manager: Adam Richards
Warehouse and Fulfillment Manager: Roger Singo

ISBN-13: 978-1-60895-815-3
Library of Congress Control Number: 2014944595
Printed in The United States of America.
10 9 8 7 6 5 4 3 2 1

Check out Amherst Media's blogs at: http://portrait-photographer.blogspot.com/
http://weddingphotographer-amherstmedia.blogspot.com/

TABLE OF CONTENTS

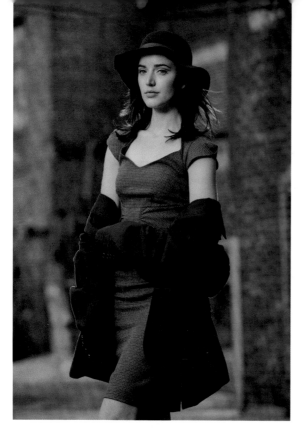

FOREWORD

by Jen Rozenbaum

I met Neil many years ago at a dinner following a local photography event. As we waited for our table to be ready, we spent some time in a cramped bar. Although we were both hungry (and the wait was long), we started chatting about photography and about life. I had no idea that Neil was a brilliant photographer—or that his knowledge about lighting was far broader than mine or most others. We were just two hungry people looking for a bite to eat.

When I got home, my stomach ached from all the laughter we shared that night—but I started Googling Neil. That's when the images started popping up. Then, I found his "Tangents" blog. Instantly, I knew that he was someone I needed to learn from if I was going to be a successful photographer myself.

I am thankful that Neil has taken time to help me learn. While I am fortunate enough to live close enough to him for face-to-face

education, this book will be joining my collection of Neil's other works for easy reference whenever I need it.

As photographers, we need a tool box—one that is full of both tangible items (like cameras, lights, and lenses) as well as many intangible skills. The most important tool in this box is our brain, which enables us to make good decisions in all the different scenarios we encounter. Our brains also allow us to plan. To be prepared is to be successful—and Neil is always prepared. He makes decisions thoughtfully and with careful calculation.

What a gift it is to get a glimpse into how his brain works and how he has created his success. Without question, it will lead to your success, too. Congratulations, Neil, on another beautiful job well done. Thank you for sharing yourself—and your beautiful art—with us all.

INTRODUCTION

Don't Be Intimidated

When I first immersed myself in photography, it took me a while to realize that the incredible photos I saw in books and magazines weren't necessarily the *first* image—or the whole story. Most often, I was seeing the one photograph that stood out in a series, or where the elements were perfectly controlled by the photographer.

With that realization, I felt less intimidated by great photos; they became more accessible—and more attainable to me as a new photographer. Photographs with impact or appeal could happen because of serendipity or foresight and careful planning by the photographer. Quite often, they result from recognizing the potential of a scene and working with it to finesse the composition, lighting, or pose.

About My Work and This Book

A photographer once told me my photography seemed to be all over the place—that it was unfocused and that it wasn't clear precisely what I offer clients. I should concentrate on just one thing and make that specific thing my own.

Well, that does make sense. While most of my work is related to people, there *is* a certain eclectic approach. Perhaps that is best explained by where I come from in my photography. At the heart of it all, I still have my amateur interest in all of photography—*all* of it. I still get excited at new discoveries, techniques, and gear. I am still that guy with my nose pressed against the camera store window, dreaming of doing things you only really read about in magazines. I still crave it all.

That also explains the motif of this book, which contains examples of all kinds of ideas and techniques as well as the thought processes behind them.

Over time, my portrait style has gravitated toward a look in which everything is quite simplified—the lighting, the background, and the framing. Whether I use the available light, video light, off-camera flash, or even on-camera bounce flash, there's an uncomplicated look. I'd like to think of it as elegant, unfussy simplicity.

The challenge is to mix it up and improvise to reach for better images every time.

In this book, I will analyze my eclectic style and show that there's usually a specific underlying method and familiar rhythm that gives me a "can't fail" baseline—a point where, at a minimum, the images look really good. From there, the challenge is to mix it up and improvise to reach for better images every time.

About the People

Some shoots were produced for this book. Others were done with models from workshops or who were originally photographed for the Tangents blog. Some are clients, some are friends.

About the Gear

For wedding photography, I need fast lenses (f/1.4, f/2.8) and responsive cameras. I mostly use the Nikon D4 currently, but that will change as I inevitably upgrade. That said, the majority of what is in this book is accessible to anyone with a DSLR.

A number of the images use studio lighting. Still, I would say most of what is presented is accessible to photographers with speedlights. You should be able to use the ideas and techniques here with a basic home setup.

What is important is that there are various tidbits and ideas in every chapter for *everyone* to learn from.

1. SIMPLIFY, SIMPLIFY, SIMPLIFY

One consistent theme you will notice in this book is how to pull amazing portraits out of "nowhere" scenarios. The final photograph will look stunning—but when the wider pull-back shot is seen, it is a mess. With selective composition, we can decide not only what we want to include in the frame but, just as importantly, what we need to *exclude* from the frame.

Note the word there: *exclude*. We need to exclude from the frame anything that doesn't enhance the image, but instead will detract from the final photograph. So an easy mantra is to simplify, simplify, simplify.

Lighting

The two main images of Elle (*below and facing page top*) were taken in the late afternoon, about an hour before the sun went down. Shooting toward the sun, I spotted this lovely open

If you can create a good photograph out of seemingly "nowhere," then you can bring a variety to your images that is out of the league of photographers who feel they have to rely on picture-perfect scenery.

available light. There was really no need for additional lighting at this point.

Lens Selection

The choice of lens here was important. The 70–200mm lens (a fast telephoto zoom with stabilization) is an essential lens for me. It allows me to shoot in low light with relatively less chance of camera shake. The shallow depth of field also adds its own characteristic to the image.

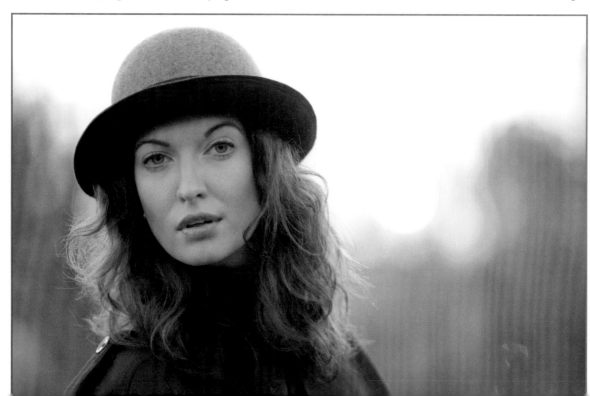

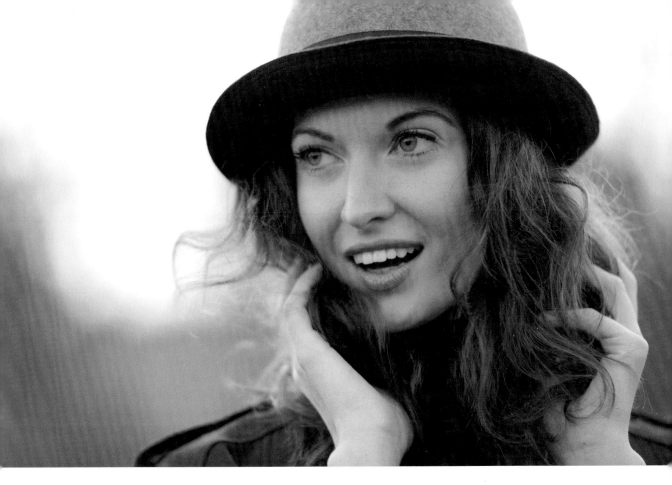

TECH SPECS:

1/200 second, f/2.8, 400 ISO
Nikon Df
Nikon 70–200mm f/2.8 VR II
Available light

More importantly here, the longer focal length allowed me to pick out the specific background that I wanted. With this lens, I can choose my background—and even a sideways movement of a few inches can completely change the background of the portrait.

The Pull-Back Shot

And here is the pull-back shot (*right*)! Trees and a car-park and a road. It really doesn't look like much. But by using the tight compression of a 70–200mm lens at the 200mm focal length, you can be very selective about the background.

In this case, I was able to shift my own position slightly and change the lighting by letting the sun just barely peek past my subject, to give a bit of flare that warms up the image.

So, really, I would highly recommend a lens in this range for any portrait photographer who regularly shoots on location.

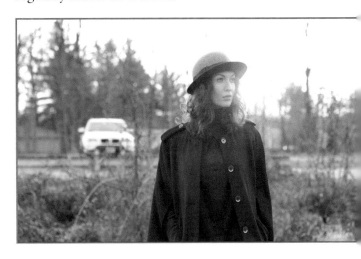

2. AVAILABLE LIGHT AND COMPOSITION

*I*n the introduction, I mentioned that very often you can distill a technique into a familiar pattern—a customary way of working where you can get great portraits in a very short time and under pressure.

With this photo session with Christy, crazy peak-time traffic delayed the start of the shoot. When we finally got underway, falling back into a familiar rhythm of shooting portraits allowed me to get images that worked—very quickly.

There's a method that helps, especially when you're under pressure. The starting point is finding that intersect between good light and a good background. And if you don't have great available light, then you need to create it with additional lighting. From there, it is a matter of posing the subject and composing the frame.

The longer lens allowed me to easily finesse my composition in relation to the background.

The Starting Point

With the sun setting over the horizon, there was a golden glow to the light. I asked Christy to turn her back to that, hoping for some of that rim-light to perhaps work its magic. Unfortunately, it wasn't strong enough for the effect I wanted—the light was already fading (*left*). Also, shooting in this direction didn't look like it would lead to much in terms of an interesting background.

A Better Option

Turning around, I saw the patch of brighter sky between the trees; I knew this would make a great natural frame. This, then, is where I shot the main image (*facing page, top*).

What It Looked Like

The pull-back shot (*facing page, bottom*) shows exactly where I photographed Christy. It's just a grassy stretch next to the side of the road—

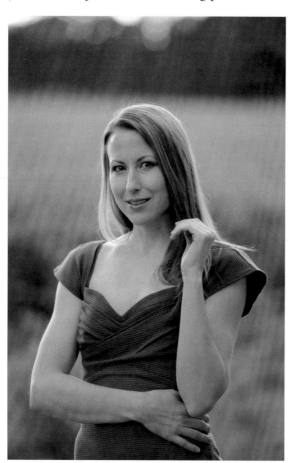

◀ The fading light didn't produce enough rim light, and the background wasn't especially interesting.

▶ Turing around, I found a better background and better lighting for my portraits of Christy.

nothing much there. The main image was shot at 180mm, which again is toward the longer end of my 70–200mm f/2.8 zoom.

Shooting from a lower angle, I framed Christy against the brighter background with that natural vignette of out-of-focus trees. None of this is random; it requires making specific decisions. The longer lens allowed me to easily finesse my composition in relation to the background.

TECH SPECS:
1/160 second, f/2.8, 1250 ISO
Nikon D4
Nikon 70–200mm f/2.8 VR II
Available light only

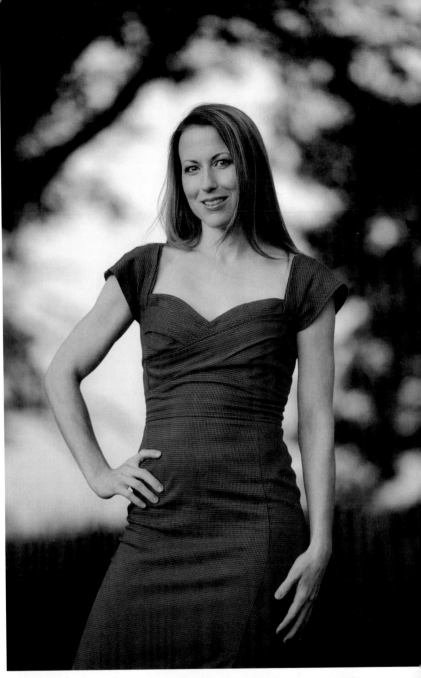

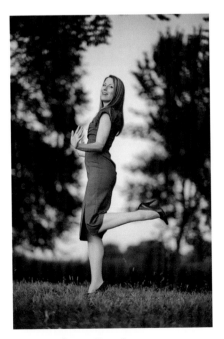

Another Option

This same scene and lighting worked for full-length images.

3. THE GAME-CHANGING 85MM LENS

*W*hile a 70–200mm f/2.8 lens can be even more effective in controlling the background, the shorter focal length of an 85mm lens can make this somewhat easier. Specifically, it's a smaller lens and therefore less intrusive when you photograph portraits. It's less "threatening" to the person you're photographing—and it's easier to carry around. With a fast 85mm lens, you can pretty much shoot anywhere and make the background look good.

TECH SPECS:

1/400 second, f/1.4, 400 ISO
Nikon Df
Nikon 85mm f/1.4G
Available light

Street Scene

Just how well can you blur the background when shooting wide open with an 85mm prime lens? Compare the first photo (*below*) with the pull-back shot (*right*) that was taken with an iPhone just for reference. This should tell you the entire story of just how the 85mm lens works its magic! I shot it from the same camera position as the final image.

By shooting wide open with the 85mm lens, I used the traffic lights as large splashes of muted color in the background. Yes, you really can

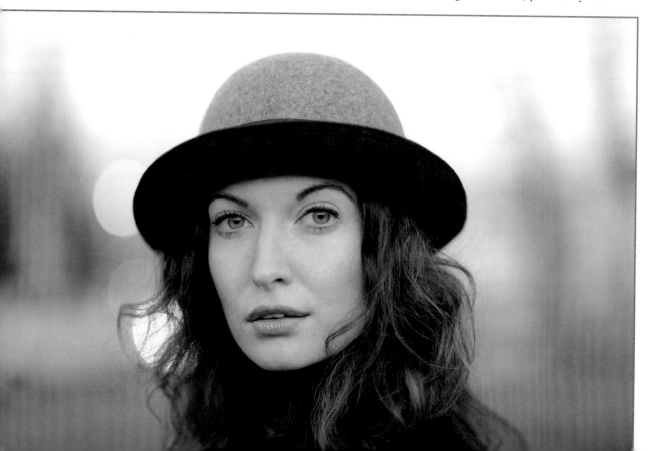

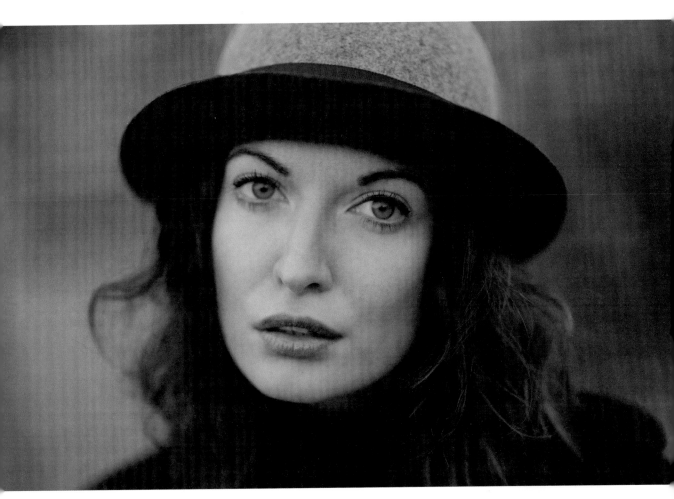

shoot pretty much anywhere when you use a wide open aperture, whether f/1.8 or f/1.4 or f/1.2

I just used available light here—no flash. With the slowly setting sun, I had lovely soft light falling on Elle.

Orange Safety Netting

The image above is another example where the wide aperture on the 85mm created a background that didn't quite seem possible.

The pull-back shot (*right*) reveals the background here—that orange safety netting. With the super-shallow depth of field, the netting merely became an interesting background and not an ugly, intrusive eyesore.

TECH SPECS:

1/500 second, f/1.4, 400 ISO
Nikon Df
Nikon 85mm f/1.4G AF-S
Available light

4. FINDING THE LIGHT

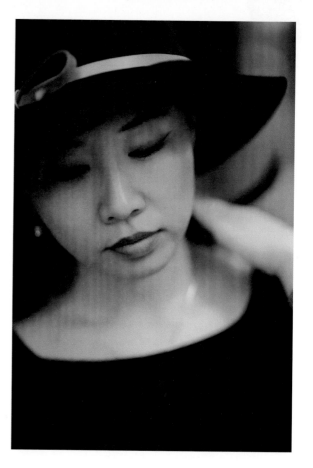

Photographing Angelica in lower Manhattan on a semi-cloudy day in the shadows of the tall buildings, I wanted light that had a bit of pop to it—not just flat and top-heavy lighting.

For a few minutes, the sun popped out, and I saw a splash of light on the sidewalk. This was where we headed for the portraits.

I looked for backgrounds along the sidewalks and storefronts that would work well with the colors Angelica had chosen for her hat and makeup. The beauty of the 85mm lens is that you can just melt your background and have it be complementary to your subject.

The 85mm prime might seem like an overlap lens if you already have a 70–200mm zoom, and to an extent it is—but the 85mm is so much easier to work with. It is lighter and smaller. The 85mm also allows a more direct way of working with your subject, without the massive lens getting between you and your subject. You can also have such shallow depth of field that just eyelashes are in focus.

TECH SPECS:

1/500 second, f/1.4, 100 ISO
Nikon D4
Nikon 85mm f/1.4G AF-S
Available light

Recommended 85mm Lenses

The faster lenses are a bit more expensive than the f/1.8 optics, but the change in depth of field is incremental. You'd get a very similar effect at f/1.8; therefore, if your budget is limited, the f/1.8 optics are excellent choices. In fact, I'd say the Canon EF 85mm f/1.8 USM is arguably their best lens in terms of optical performance *vs.* price. Similarly, the Nikon AF-S 85mm f/1.8G lens is an optical gem at an affordable price.

Photographers with crop-sensor cameras will of course wonder if a 50mm f/1.4 will give similar results. Since the crop will force a different perspective for the same composition, effectively giving that longer focal length's field of view, you'd get a similar effect with shallow depth of field. While I think every photographer should have a 50mm lens in their bag somewhere, the 85mm on a crop-sensor camera will be even more awesome in giving that shallow depth of field.

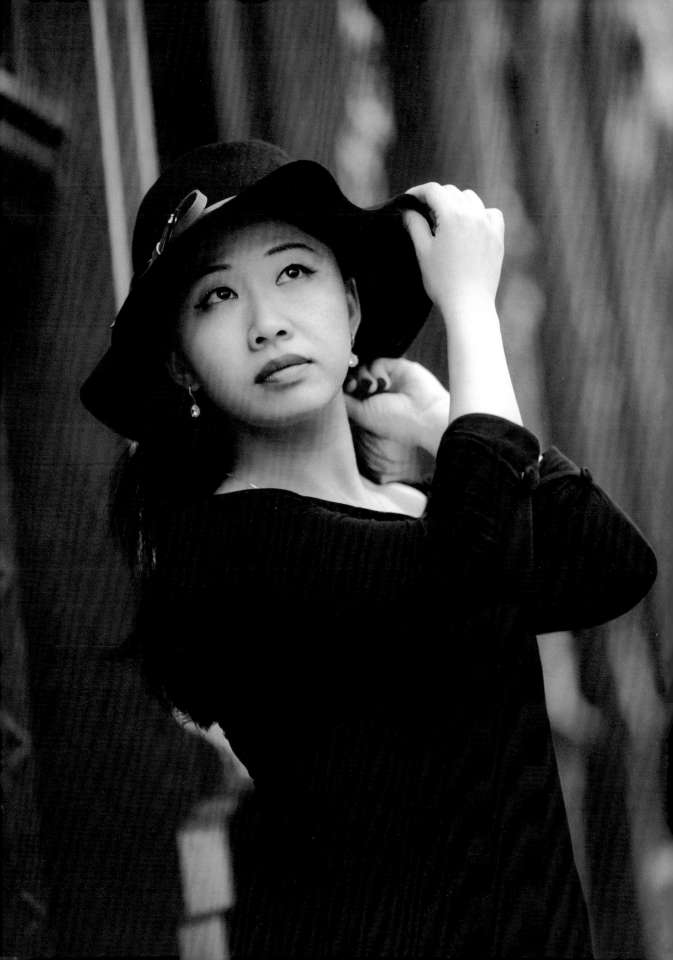

5. NATURAL RIM LIGHT

Subject Position

With this straightforward portrait (*below*) of Irene, a photographer friend of mine, I want to show a neat little trick for helping your subject understand where you want them to stand.

Here, we had random reflections of glass structures in Manhattan, giving random spotlights (*right*). I wanted to use one of these spots of light as naturally found light for Irene, and another splash of light to give a highlight behind her, as I framed her against it.

Instead of giving your subject incremental instructions ("a little to the left, a little to the

▲ Positioning the subject according to her shadow.

left—no, come back . . .") the simple trick is to point out this highlight to your subject and have them move until they see their own shadow in the splash of light. Then, they just turn around and they are perfectly placed!

At the same time, take care in looking at how the light falls on your subject's face. Aim to have clean, open light with no shadows under the eyes.

Rim Light

This exact same idea can be used in another way. For the next image (*facing page*), I had a

By watching this as she stepped to the side or forward and back, she could immediately place herself correctly . . .

similar spot of reflected light from behind my subject, giving me a bit of natural rim light. Irene, facing the camera, now just had to keep an eye on where the shadow of her head fell. As long as the top of her head stayed within the spot of reflected light, she was able to see her head in the shadow on the ground. By watching this as she stepped to the side or forward and back, she could immediately place herself correctly—without me giving continual (and possibly confusing) instructions as to exactly where she should stand.

You can do the same with someone just stepping out from under a canopy or veranda, with the sun from behind. By watching their own shadow, they can position themselves so that the sun from behind just gives a lick of color to their hair. Again, it is a simple technique that makes an on-location photo session easier.

6. SELECTIVE COMPOSITION

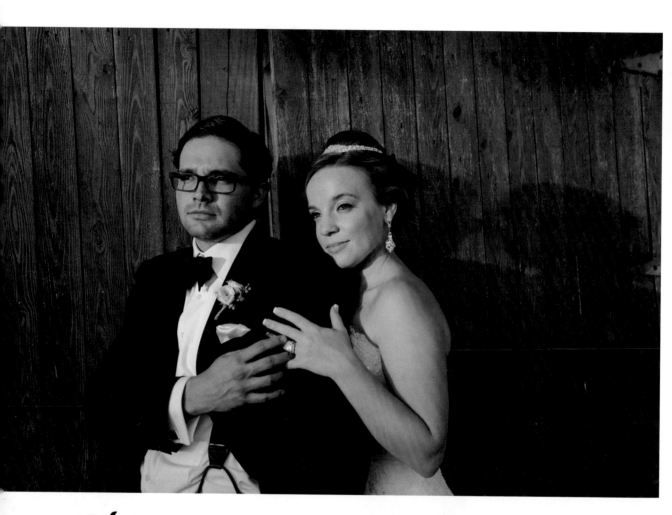

*F*raming very selectively in-camera, you can very often pull quite a surprising image out of "nowhere."

With Julia and Luis's wedding, I roamed around the reception venue, a bed-and-breakfast on the Jersey shore, for interesting spots. There were appealing nooks and crannies that would work for the romantic portrait session, but I also like adding variety—especially unexpected variety.

A Good Find

I went through a back gate, and into a parking lot behind the venue. This gate was at the delivery entrance for the venue's kitchen—and the parking lot was, well, just a parking lot. But, I loved the texture of the wooden fence and gate, and the late afternoon sun really brought out the texture. I hurried back inside and asked Julia and Luis to join me, saying, "I think I may have a great idea!"

You really have to compare the final images (*right and facing page, top*) with the pull-back shot (*facing page, bottom*) to see what was "rescued" from a "nowhere" location. The tight composition eliminated all the clutter. Julia was standing on a ramp for the deliveries. This helped bring her up to Luis's height and made it easier to have her snuggle in close behind him.

Subject Tone

An interesting observation here with the positioning of the subjects: if Julia had been in front of Luis, her dress would have been very white and his suit would have blended into the shadow areas behind him. By positioning them like this, the white dress was "sandwiched" between the darker suit and the shadows. This balanced the image better and drew more attention to their faces.

TECH SPECS:

1/250 second, f/5.6, 200 ISO
Nikon D4
Nikon 24–70mm f/2.8

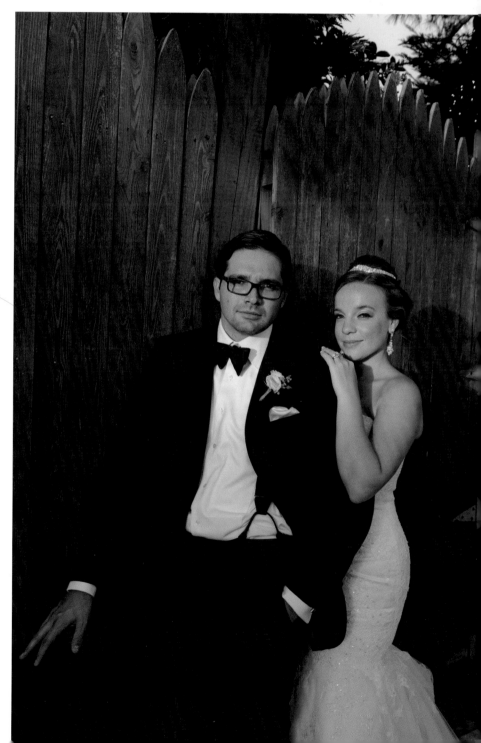

7. LENS COMPRESSION

The setting for photographing Will and Ian was a car park, but I knew that the sun on the autumn colors would be a fantastic background. The light from the front on the boys was just the open sky—soft and even. There was really no need for additional light.

▼ Image shot at 135mm.

The pull-back (*above*) shows the approximate position I shot from. And, again, you can see this is a "nowhere" location. Aside from the glorious colors in the background, there isn't anything else to work with here.

Perspective and Compression

When compressing the perspective, the technique is simple. Using the longest focal length you can (if you have a zoom, you zoom to the longest length) and then step back to frame the shot properly. Don't zoom in—*step back* until you have your framing. This will give you the maximum amount of compression.

With the initial photos (*left top and bottom*), I started at 135mm and progressed to the 200mm end of my 70–200mm lens. But I felt there was still too much of the parking lot's railings in the photo. I needed tighter framing. So I added a 1.4x teleconverter. With this, the 200mm focal length setting became an effective 280mm length (*facing page*)!

▼ Image shot at 200mm.

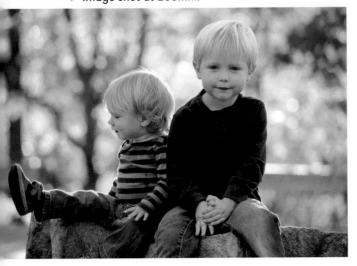

Comparing the image shot at 280mm to the one shot at 200mm, you can see the boys are about the same size in the framing of the photo. By stepping back until I got the framing I wanted of the two boys, the background became "enlarged" with the longer focal length.

By using this tighter framing, I was able to eliminate more clutter from the background and have just the two boys against this golden splash of color.

Pack a Teleconverter

With all this in mind, I do keep a 1.4x teleconverter in my camera bag. It is so small that it barely takes up any space. But when I need that extra bit of reach with my longest lens, it is just the ticket.

With this tighter framing, I was able to eliminate even more clutter from the background . . .

▼ Image shot at 280mm by adding a 1.4x teleconverter.

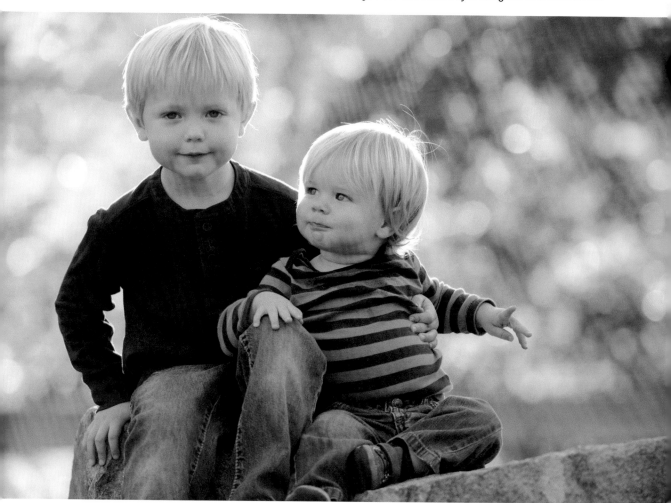

8. OFF-CAMERA FLASH FOR EXTRA DRAMA

I liked the way the dots in this background were repeated in Olena's dress, but in reverse—white dots on black, instead of black dots on silver. I also asked Olena to really exaggerate the curve of her body to create an S-shape that contrasted boldly with the rigid pattern of the background.

Ambient Exposure

The first step was determining the ambient-only exposure, which was ¹⁄₂₀₀ second and f/4 at 200 ISO. The available light was pretty sweet—soft and flattering (*below*)—but it lacked punch and looked just a bit too bland. It needed a little drama.

Off-Camera Lighting to the Rescue!

To allow the flash to have impact, I chose to underexpose the ambient light. Therefore, I

▼ With no added lighting.

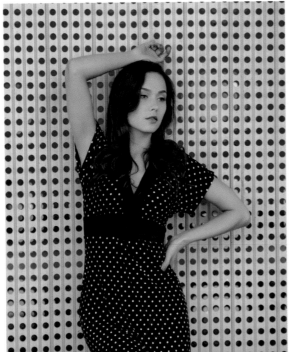

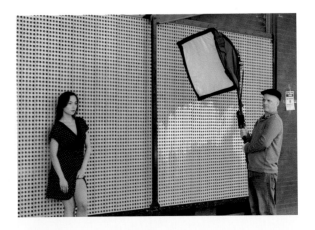

Closer = More Power

We had to hold the softbox fairly close to her to still get correct flash exposure as we changed the aperture to pull down the ambient light by up to 3 stops. The more dominant flash allowed her shadow to become a subtle element of the composition.

pulled this exposure down 2 stops (to ¹⁄₂₅₀ second and f/7.1 at 200 ISO) for the TTL flash exposure. I could have pulled down the ambient exposure by 1 stop, or 2 stops, or 3 stops—or anywhere in between. The more I underexpose the ambient light, the more contrasty the final image will appear—and, hence, the more dramatic.

There is sometimes a kind of snobbery where photographers insist that available light is better. This clearly shows that, with additional lighting, I have much more control over the final image.

▶ The final image with TTL flash and the ambient light underexposed by 2 stops.

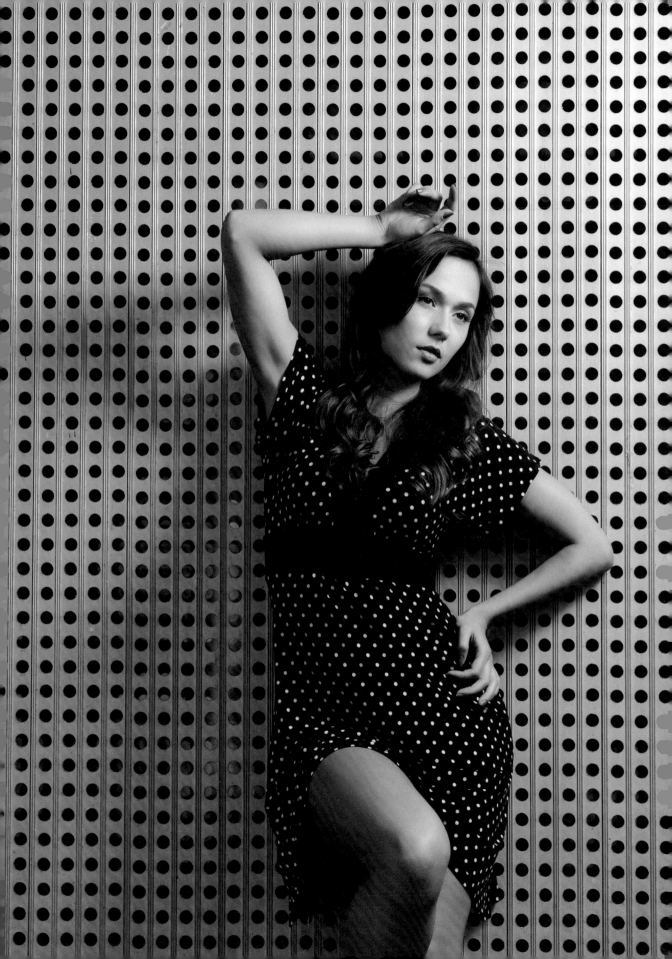

9. ELEGANTLY SIMPLE ON-LOCATION

*F*or most of my on-location portraits, I like to travel (fairly) light, and my lighting of choice is a speedlight with wireless transmitters and a softbox. The softbox is either held up by a light stand (which I weigh down with my camera bag) or by an assistant (holding the softbox on a monopod).

▼ With no added lighting.

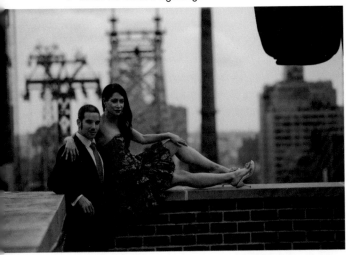

▼ A pull-back shot of the overall scene.

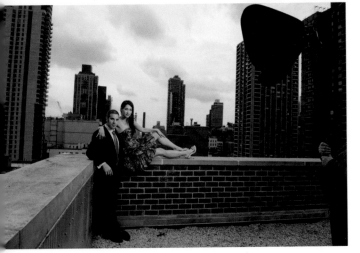

Ambient Light Plus Flash

Let's look at the progression. The first image (*top left*) is the photo without the additional light. My basic exposure was chosen so that the background wouldn't blow out in overexposure.

Then, flash was added (*facing page*). I like TTL flash—it often gets us there faster than manual flash. But for consistency, especially when photographing someone in a static position relative to the light, manual flash is the only way to go. At this distance and aperture, and using the softbox (which cuts down on the flash's light), I was close to full manual output on the flash. But this is where I decided I wanted to be in terms of balancing the flash exposure with the background.

> I like to travel (fairly) light, and my lighting of choice is a speedlight with wireless transmitters and a softbox.

This simple lighting setup works for so many on-location portraits, and is most often my starting point. It just works.

Concept and Posing

Before we got underway, I talked with Allison and Scott about the idea and feel for this photo session: glamorous—a "night on the town" kind of glamorous. For this New York rooftop location and that dress, a vertical photo wouldn't have made much sense. Too much would have been "lost" against the drab brick wall as the background.

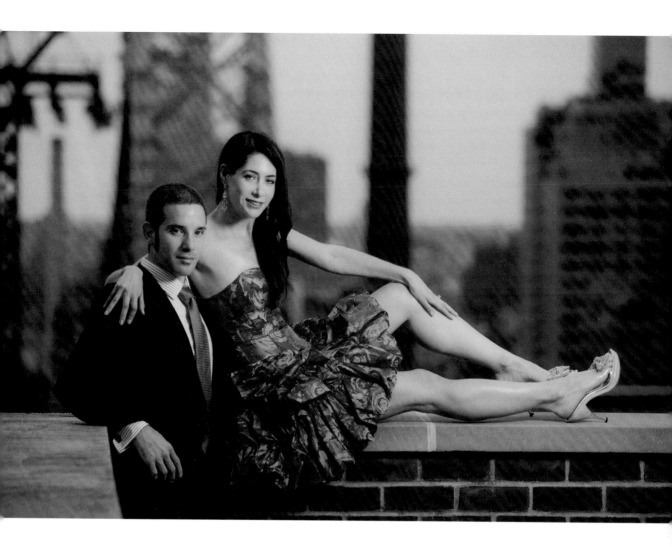

The pose was a compromise between something sexy/glamorous and the practical need to have Allison not feel unsteady on the (wide) ledge there. Scott had his arm around her and I also asked Allison to drape an arm over Scott's shoulder. In this way, the pose developed out of the environment and background.

TECH SPECS:

1/250 second, f/5.6, 100 ISO
Nikon D4
Nikon 70–200mm f/2.8 VR II
Manual off-camera speedlight in a softbox

For this New York rooftop location and that dress, a vertical photo wouldn't have made much sense. Too much would have been "lost" against the drab brick wall.

10. INTENTIONAL USE OF FLARE

For these promotional photos of aspiring model twins, Carina and Carolina, we went to a park. There are certain things I look for when working on-location that I know will immediately give me a better chance at successful portraits. The method here should be quite obvious by now.

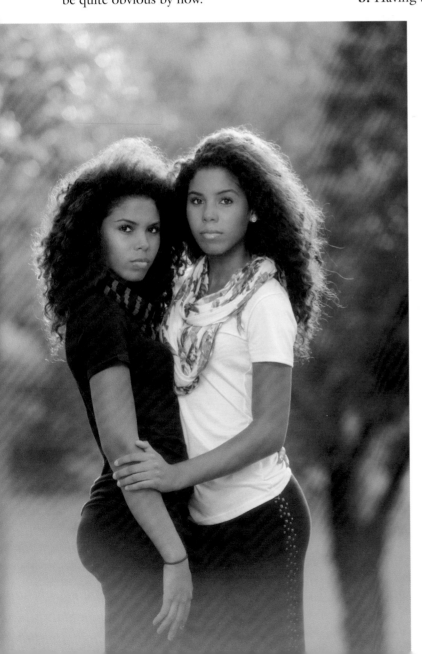

1. A long lens (a 70–200mm used closer to the longer end) to compress the perspective.

2. Shooting with the background further away, to defocus it as much as possible.

3. Having the subject(s) with their back(s) to the sun or strong light, which also creates rim lighting. This helps with the separation of the subject(s) from the background.

4. The use of off-camera flash (with a softbox) to give flattering light as the main light. This light is set to enhance the available light, or to balance the exposure for the subject with that of the background.

It's a recipe that easily gives you solid results in most cases.

Lens Flare

Shooting toward the setting sun, the lens started flaring. I could have minimized this by blocking the light with my hand (or a gobo), or I could

TECH SPECS:

1/250 second, f/4.0, 640 ISO
Nikon D4
Nikon 70–200mm f/2.8 VR II
Manual off-camera speedlight in a softbox

Being Themselves

Let your subjects be themselves—especially if they are as naturally photogenic and spirited as these two girls. This is an important part of being successful with portraits: allowing your subjects to be themselves and then guiding them to show some aspect of their personalities. Or, it might just be your job as the photographer to present them at their best.

With Carina and Carolina, I spent a fair amount of time just photographing them dancing and laughing. This was very much part of the process to effortlessly get images that they like. After shooting a few sequences like this, I showed them the images and they loved them. Having their confidence, it was easier to guide their natural poses a bit into the final images, which were ultimately what we were after all along.

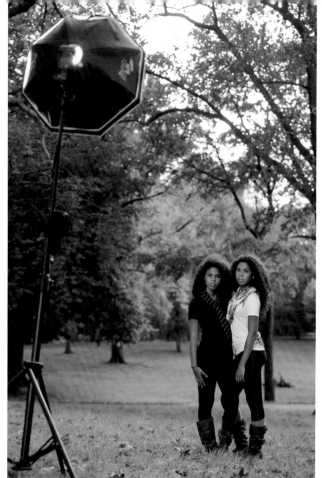

have moved the setup so that I had trees blocking the direct, strong light hitting the front of my lens.

In this case (*facing page*), however, I liked the look of the flare—I felt it added warmth. By moving my own position around, I could control the flare so that it gave a natural vignette to the bottom part of the image, neatly mirroring the warmer, brighter top part of the photo.

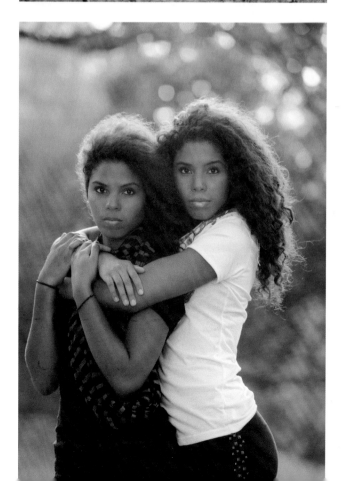

11. **ADD RIM LIGHTING**

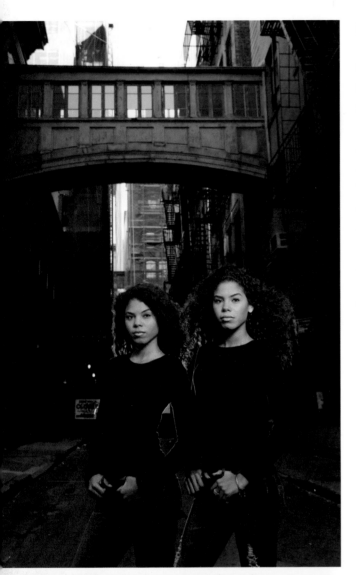

*O*nce you're comfortable using a single off-camera light source, such as a softbox (or undiffused flash), there's an easy next step to give a little bit of zing to the image: add rim lighting!

Add a Second Light Source

I most often work with just a single softbox when photographing portraits on location. As shown in section 10, having the sun behind your subject creates natural rim lighting. This helps separate your subject from the background. It's not just the shallow depth of field that helps create that nearly three-dimensional effect where your subjects just pop out from the background—rim lighting from behind also helps bring more attention to your subjects.

Adding a bit of rim light was essential and gave just enough of a highlight to define their outlines.

Using additional lighting, such as a second flash, is the way to create the same effect when there is no natural rim lighting. The best part is that it is really simple to set up and use.

TECH SPECS:
1/125 second, f/8, 800 ISO
Canon EOS 6-D
Canon 24–70mm f/2.8L II
Two manual flashes, one in a 1x3-foot gridded softbox

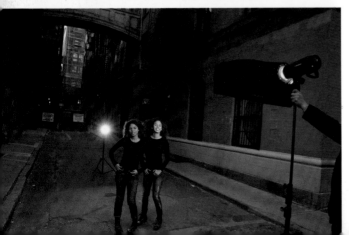

When working in a darker environment, like this urban scene (Staple Street in New York City), twins Carina and Carolina's dark tops and dark hair would just have blended in with the background. Adding a bit of rim light (created by a second light source behind them) was essential and gave just enough of a highlight to define their outlines.

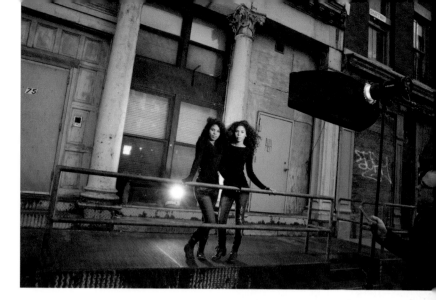

The delightful twins are always energetic and fun to shoot—but on this cold day it was imperative to set up fast and shoot quickly. For the first image (*facing page*), I used a bare Profoto B1 portable studio unit behind them for rim light. The main light on them was a 1x3-foot gridded stripbox.

A Second Setup

The next setup (*right*), was very similar. I also wanted some rim light behind them, so I placed a B1 flash on the ground, propped up by a lens case to angle the light upwards.

This technique of using a softer light source as the main light on my subject(s) with a flash from behind them for rim lighting is a standard setup that always gives me really good results when I need to separate my subject(s) from a darker background.

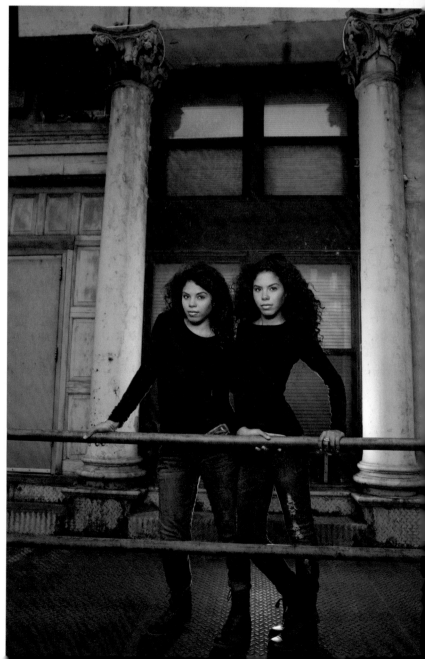

12. BACKLIGHTING

Two speedlights were used here for the lighting. One was in a double-baffled softbox as a main light from the front. The second light was a bare speedlight placed behind the model to produce the rim lighting and help create some separation. Both lights were set to manual output and controlled wirelessly by PocketWizard TT5 triggers.

Exposure Metering for Manual Flash

Using a double-baffled softbox means that we can't just use the guide number of the flash. We have to use some other method to determine the exposure. While using a light meter is the most accurate way to get to correct exposure for flash, it becomes relatively easy (with experience) to accurately "guess" the exposure. But really, there isn't that much guessing involved.

With manual flash exposure, four factors are involved: distance, power, aperture, and ISO. The baffles in the softbox obviously affect the power of the flash.

Therefore, it's helpful to become familiar with how much light your specific off-camera flash setup delivers. Again, this comes with experience. Let's say that you know that for X distance, you can get f/5.6 at 400 ISO when you set

▶ *(top)* The model photographed without added backlighting. Compare this to the final image on the facing page.

▶ *(bottom)* The pull-back shot gives a sense of placement of the lights.

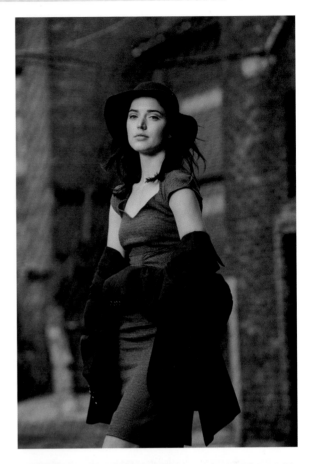

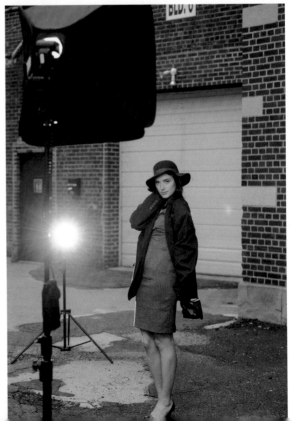

TECH SPECS:

1/200 second, f/4, 100 ISO
Nikon D4
Nikon 70–200mm f/2.8 VR II
Two flashes, one in a softbox

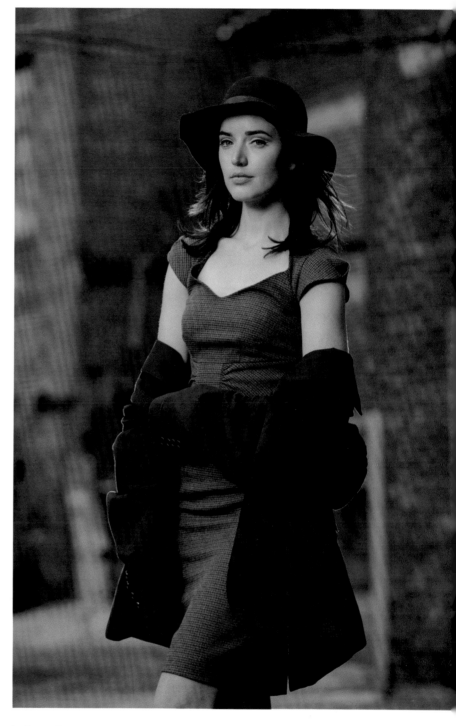

your flash to Y power. Then, you know if you meter for the ambient light, you can adjust your power setting, and/or the aperture, and/or the ISO.

Let's work through this specific example. For the final image (*right*), I had my camera set to $^1/_{200}$ second at f/4 and 100 ISO. Those settings were chosen so that my ambient exposure for the model, Anelisa, was under by 1 stop or so—just enough so that with the flash I'd be able to control the quality of the light.

That was my starting point: I wanted f/4 at 100 ISO. For my specific setup, I know from experience that I will get correct exposure at X distance when I set my camera to f/5.6 at 400 ISO, for a speedlight in this softbox, when I set it to $^1/_8$ full power.

The backlight doesn't add to the actual exposure, so I concentrated mostly on adjusting the output of my main flash. I can count the $^1/_3$ stop indents in power as I change my aperture and ISO accordingly—and, in that way, set (close to) the correct exposure simply by frequent experience in working with one specific setup.

13. A SUN-DRENCHED BACKGROUND

*I*n many of the previous portraits (see section 10, for example), we relied on the sun to give us backlighting. This also makes it easy to get that warm, slightly sun-drenched look. But when shooting on-location, it is sometimes up to *you* to create the illusion of sunlight—just to spark up the image a bit. If you are working in an area where there are trees and leaves that will catch the light from your background light, it is relatively easy.

Setting

Cara Lee is a photographer in upstate New York. Meeting up at a Poughkeepsie campus, it was a bit of a struggle on this late afternoon to find settings where the light had some snap to it. One of the spots that we shot in was this pathway. It

had potential as a setting. The sun was already getting closer to the horizon, but the trees in this location were blocking most of the sunlight at this time of day. It looked a touch too drab. Off-camera flash to the rescue!

Lighting

The sequence of test shots below show how I built up the final look (*facing page*) with two speedlights. The available-light only shot (*below left*) shows what the portrait would have looked like without any additional lighting.

For the second image (*below right*), I added a speedlight pointed up into the trees in the immediate background. This created the impression of sun shining through the leaves. The final step was adding a speedlight in a

▶ *(left)*
The scene and subject with available light only.

▶ *(right)*
Backlight added to create the look of sun through the trees.

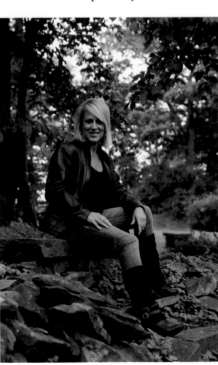
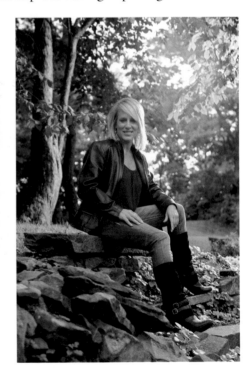

TECH SPECS:

1/200 second, f/4, 800 ISO
Nikon D4
Nikon 24–70mm f/2.8
Two flashes, one in a softbox

softbox for the flattering main light on my subject (*right*). The wider shot (*below*) shows the relative placement of the two lights. My own position for the final image was closer to the main light.

The flashes were set to manual and adjusted to an approximate output based on experience. (The thought process here was explained in section 12.)

With that, we have a simple configuration that will help in many similar situations—a backlight to give some rim light (and even simulate sun shining down) plus a main light to give great portrait lighting. It's simple but effective.

▶ The final image.

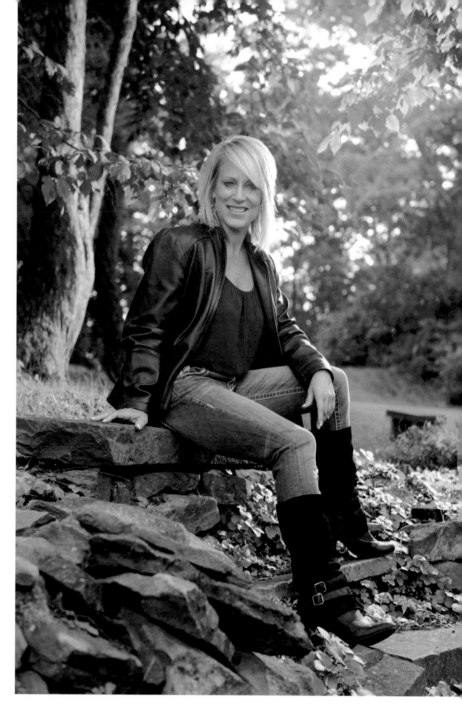

▼ The two lights in place.

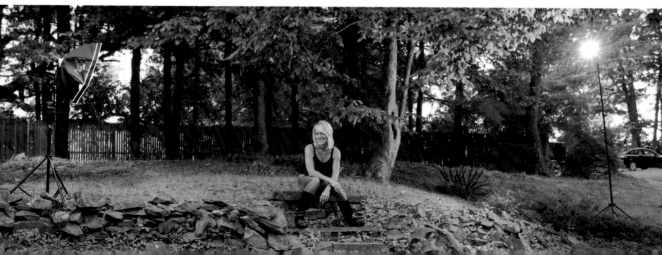

14. LENS FLARE AND POSTPRODUCTION

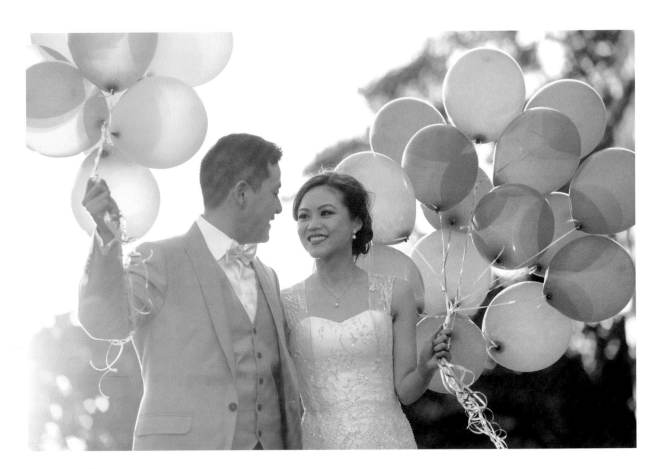

Shooting toward and even into the sun for strongly backlit images can give us lens flare. Some photographers embrace this; others insist that this is something that modern lens technology tries to avoid. Personally, I like it—it can add variety to your images.

The main image (*above*) had the sun behind Eric and Peiwen. Exposing for the couple, the image (straight out of the camera) looked desaturated, but this was easily corrected by adjusting the RAW (or JPG) file for a cinematic look that appears sun-drenched and natural.

An Extreme Case

Let's look at how to correct for an extreme version where the backlighting completely desaturated the capture. With a few easy adjustments, the basic file will look pretty good!

With the first image (*facing page, top left*), the lens flare was really out of control—to the point that the photo on the camera's LCD showed mostly as white, as if there were no image. (I shoot in manual exposure mode, so when the sun really hits the front element from a specific angle, the image washes out like that.)

▲ In this capture, the lens flare is out of control.

▲ The histogram shows detail that can be pulled back.

However, looking at the blinking highlights on the camera or in Photoshop (*above*), you can see that not much of the scene is actually grossly overexposed to the point where there is no detail. So there is detail that we can pull back!

Looking at the RAW file's histogram (*top right*), you will see that the tones are really compressed. We can start returning this image to something more aesthetically pleasing by pulling down the Black Point slider, spreading the tonal range between black and white. Then we can adjust the other sliders—Exposure, Contrast, etc.—to taste (*right*).

▲ Adjusting the sliders in Camera Raw.

▼ The final image.

In this way we finally have an image that is interestingly sun-drenched and has a certain flavor (*bottom*).

Note: The darker area at the bottom is the videographer's hair. I purposely held my camera lower for a few shots to include something as an out-of-focus border. This helped anchor the radiant flare in the top of the image.

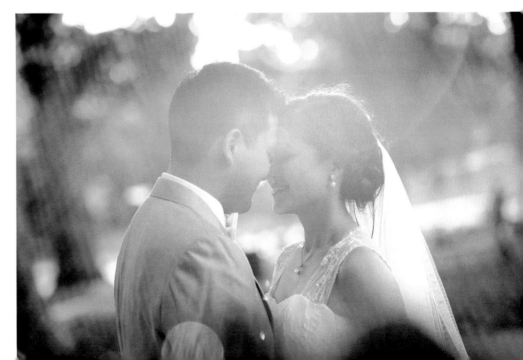

15. **STRIVE FOR VARIETY**, PART 1

Tatiana Daubek is a Baroque violinist and a Master of Music in Historical Performance from the Julliard School. The photo session with Tatiana was one of those instances where, once the lighting and subject position were worked out, I let my model be herself with little direction.

Lighting

Looking at the test shot (*top left*), you will see there was a lot of available light streaming in from camera right, but there was also some light reflected off the wall. This can be seen more clearly in the comparison photo (*bottom left*). While the test shot has uneven light on Tatiana's

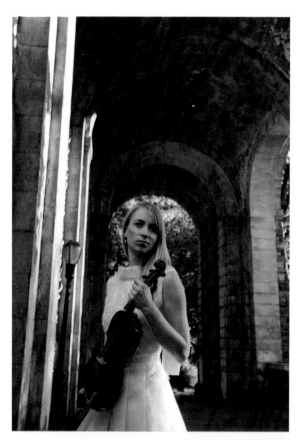

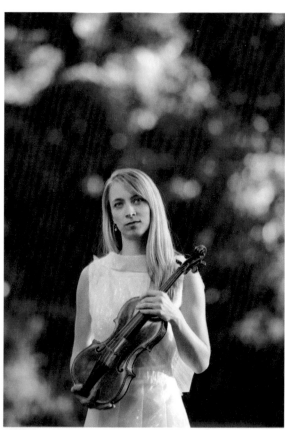

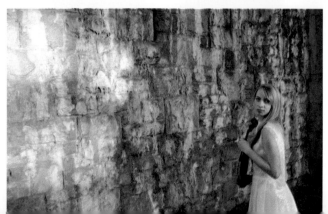

◄ *(top)* The test shot shows the available light.

◄ *(bottom)* Pulling back, you can see the light bouncing off the wall.

▲ Careful adjustments to Tatiana's position allowed me to get nice lighting on her face.

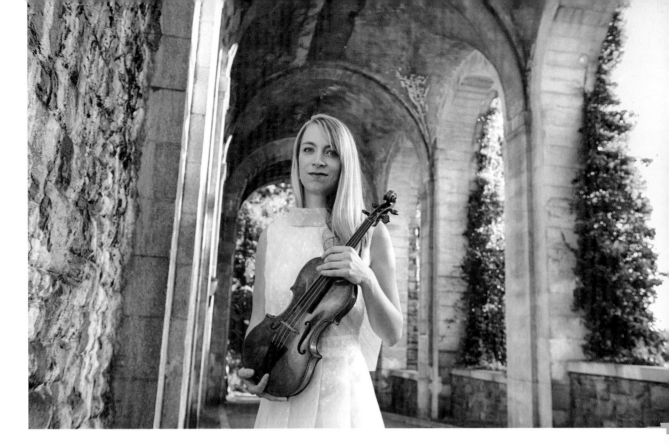

face, posing Tatiana toward the cliff face let me use it as a massive reflector for beautiful, soft light. From there, it was just a matter of positioning her so that there were no hot-spots from the dappled light streaming in from camera right. Minute adjustments in the pose helped me get this right (*facing page, top right*).

Diverse Approaches

In this and the next section, I want to emphasize the diverse approaches one can take during a single session, adapting to what is available in the location and lighting—small adjustments that help give variety to the final selection of images.

Especially when doing a session on location, the ideal is to get as much variety as possible in terms of posing, angles, and composition. Shoot

TECH SPECS (FACING PAGE):

1/100 second, f/4, 500 ISO
Nikon D4
Nikon 24–70mm f/2.8
Available light

TECH SPECS (ABOVE):

1/200 second, f/3.2, 400 ISO
Nikon D4
Nikon 70–200mm f/2.8 VR II
Available light

details. Shoot vertical and horizontals; shoot wide and tight. Don't stay fixed in one spot. Even a slight shift in your position can dramatically change the background and the balance of elements in the frame (*above and next page*).

Location Selection

In terms of the location, I wanted a background that seemed fitting—not urban, but also something that would not be at odds with a Baroque look. Fort Tryon Park had some structures and arches that I felt would work. For this sequence, I chose these arches as a natural frame. Shooting with a longer lens, as I often do to compress the perspective, I just made sure to frame her against the row of arches receding in the background.

16. **STRIVE FOR VARIETY**, PART 2

The Same Setting—But with Flash

In the previous section, featuring the same session with Tatiana Daubek (more on her at www.tatianadaubek.com), I was able to use just available light by carefully positioning her. When

TECH SPECS:

1/200 second, f/3.2, 200 ISO
Nikon D4
Nikon 24–70mm f/2.8
TTL flash main light; manual flash rim light

I started the photo session, however, I used off-camera flash.

This kind of flexibility in the use of light, and in the use of off-camera flash, is necessary if we want to use the full range of our lighting abilities—from the very subtle use of light to blasting as much light as the sun.

The First Look

When you add flash, it is much easier to get perfect lighting in relation to an interesting background. The first image (*bottom left*) is typical of the initial sequences we shot.

Mix It Up

As always, it is important to get different angles and different compositions—vertical/horizontal and wide/tight. This image was created with the same "kiss of light" setup seen on the facing page.

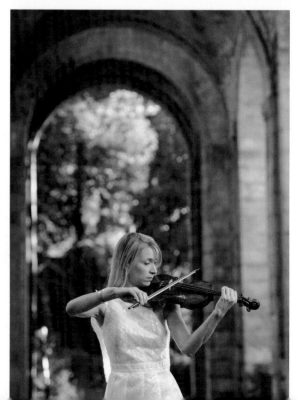

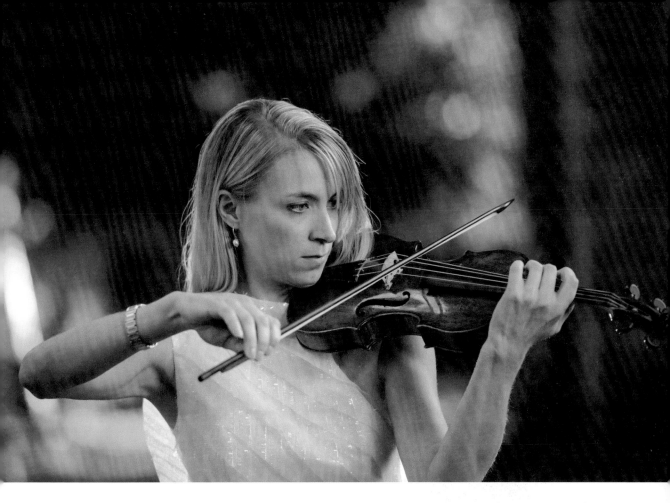

A Kiss of Light

Later on, working in the same area where the available light series (in section 15) was shot, I used off-camera flash in a more subtle way to enhance the image.

The second image (*above*) shows that proverbial kiss of light from an off-camera flash in a softbox. It was used just to sweeten the light. It also ensured that no matter how she moved around in that spot, that there would be clean light on her. Since the available light was pretty good,

I was able to add a touch of flash so delicate that, hopefully, it isn't obvious that off-camera lighting was used at all.

The pull-back shot (*below*) shows that there was a second flash to add a bit of rim light for separation.

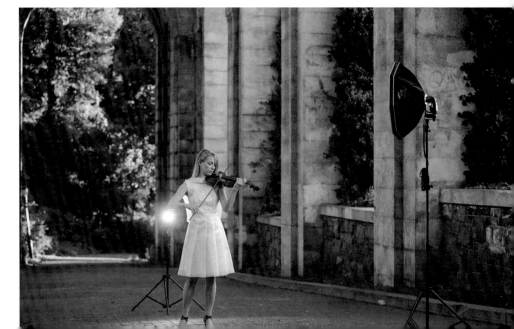

17. DRAMATIC LIGHT

Sarah and Mark were in New York, dressed to the nines, to attend a Rockettes show. While they were dressed up, and with some time before the show they were attending, we did a photo session. The New York skyline at dusk worked as a perfect backdrop for their stylish attire. (I asked Mark if he felt like James Bond, all suited up like that in his tux.)

Lighting

The lighting setup for this photo session was quite straightforward. The main light was a speedlight in the Lastolite Hot Shoe EZYBOX Softbox Kit (24x24 inches). The rim light was another speedlight behind them, with the plastic diffuser cup on.

You can see from the photo below that I angled the softbox upward, forcing the light to fall off toward the bottom of the frame. I didn't want to light up the ground. I also didn't really need their legs and lower bodies to be lit up as well as their faces. Angling the main light helped me to accentuate their upper bodies and faces.

Experience has given me a good idea of what the speedlight's output will be when used in that specific softbox.

The speedlights were controlled manually. TTL flash would just have been hard work here. I would have constantly needed to control the flash exposure compensation for each shot because of the large areas of dark tones. So manual flash it had to be.

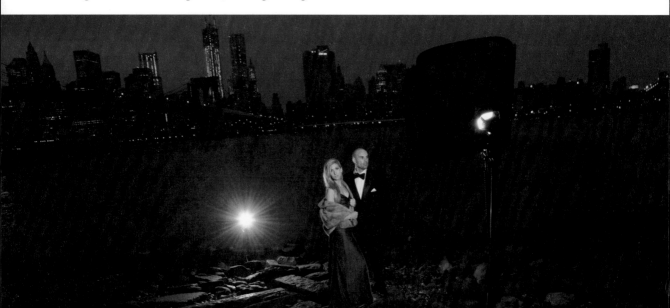

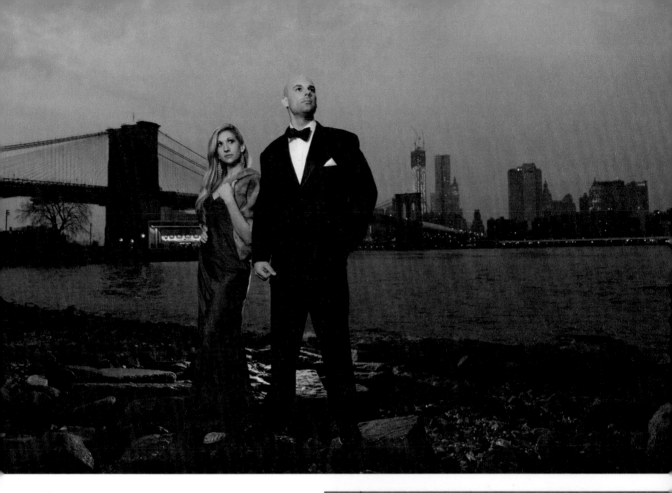

TECH SPECS:

1/60 second, f/5.6, 800 ISO (above)
1/50 second, f/5.6, 800 ISO (right)
Nikon D4
Nikon 24–70mm f/2.8
Manual flash in softbox (main light) and with diffuser cup (rim light)

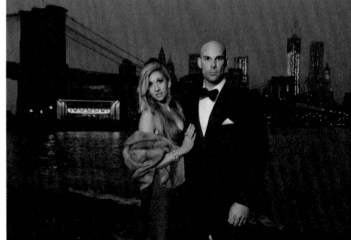

I didn't meter for the flash. As explained in section 12, experience has given me a good idea of what the speedlight's output will be when used in that specific softbox. The rim light was also adjusted by eye.

I manually controlled the speedlights' output from my camera using a PocketWizard AC3 Zone Controller on top of a PocketWizard FlexTT5 transceiver. Each speedlight had its own PocketWizard FlexTT5 transceiver.

As we were shooting, the ambient light was fading. Therefore, I adjusted my shutter speed a little bit as I continued shooting the sequence, but still with the intent of keeping the New York skyline a subdued background.

18. **GELLED FLASH AT SUNSET**

*L*auren and Chris were posed at a breathtaking vantage point overlooking Manhattan. The setting sun poured gorgeous warm tones on the scene. Since the couple was in a shaded spot, I had to add lighting—but I wanted to make it appear as if they were bathed in the same warm light as the scene.

Color Temperature

The light from speedlights has a relatively cold color temperature (bluish), so it can create an unpleasant color cast when paired with warm ambient light. A typical problem situation would be in the incandescent environment where we often find ourselves working at night. But there

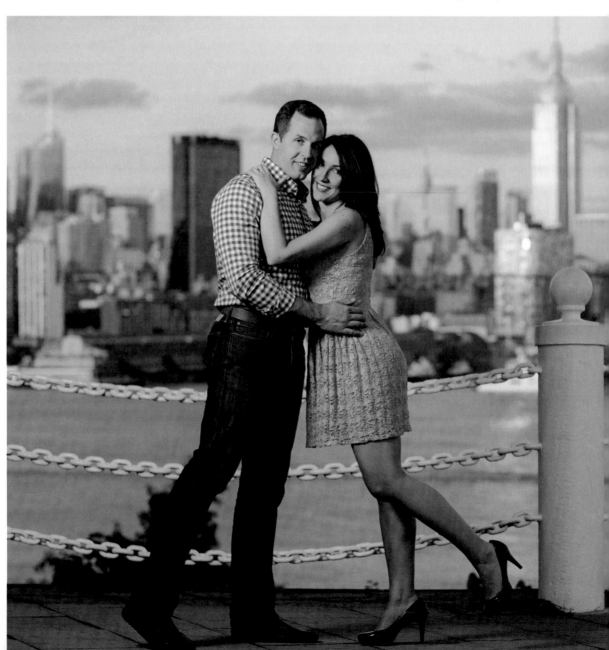

are other times, such as this, when the white balance from our speedlights (around 5400K) is also too cold (blue) compared to the existing light. Then, gelling the flash is the answer.

Gelling the Flash

I frequently use gels to turn the white balance of my flash warmer, usually to balance it with incandescent light. I cut out a piece of gel and tape it to the top of my speedlight's head. One inexpensive sheet will give you a huge supply of these gels. I normally keep a ½ CTS gel taped to my lens hood for ready access.

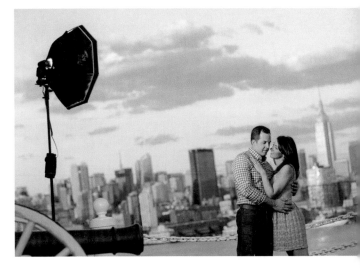

TECH SPECS:
1/250 second, f/3.5, 100 ISO
Nikon D4
Nikon 24–70mm f/2.8
Off-camera TTL flash

In this case, my goal was to have the same warm light on the couple as there was on the city. The ½ CTS, measured for 3700K, would have been too warm for this. So instead of covering the entire face of the flash with the gel, I only partially covered it, letting some of the flash not be gelled. This was just enough.

▼ A full CTS will bring your flash white balance down to around 2900K, more or less neutralizing the look of tungsten light. A ½ CTS will bring your flash white balance to around 3800K, which will leave your backgrounds with a touch of the warmth of tungsten lighting.

19. BOUNCE FLASH IN THE NIGHTCLUB

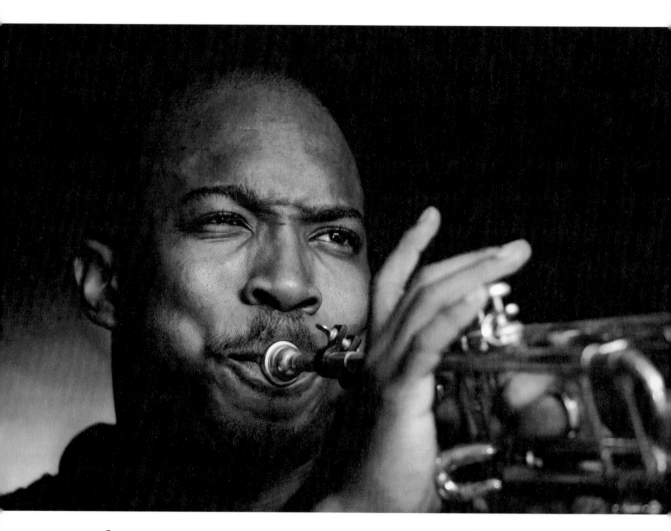

*K*evin is a jazz trumpet player, and he was photographed during a session in a club. I was invited by the band to photograph them as they played one afternoon.

A Lighting Challenge
Since the lighting in the club was challenging, I resorted to on-camera bounce flash. It's a perfect example of how I use on-camera bounce flash so

that it looks nothing like on-camera flash. The light in this image is nearly all from my

TECH SPECS:

1/250 second, f/4.0, 800 ISO
Canon EOS-1D Mark II N
Canon 70–200mm f/2.8 IS
On-camera TTL flash at +1 FEC

▶ Just to show what the available light levels were like, here is an out-of-camera image shot at ¹/₁₆₀ second and f/1.8 at 1600 ISO. As you can see, the image is underexposed even at those settings.

flash. The red hue in the background, and spilling onto part of the trumpet and his skin, was from the strong red lights in the nightclub. To minimize this, I underexposed the ambient light, letting the flash become the main source of light. Doing this allowed me to control the quality of light.

How to Bounce Flash

Here are the key points that reveal how I achieve quality light with on-camera bounce flash.

1. I bounce the flash into the direction I wanted my light to come from—*not* toward my subject. This is a crucial element.
2. I don't bounce my flash off a specific surface but, rather, in a specific *direction*—the direction I want my light to come from. Even though the light levels were low here, I was bouncing flash off the ceiling and brickwork (in fact, off anything to my right and behind me).
3. To prevent any direct light from the flash spilling on my subject, I use a piece of black foam to flag the light from my flash. Since there is *no* light coming from the camera's

viewpoint, the resulting light on the subject is directional.

This isn't an efficient way of using flash, but the light that returns is sweet indeed. You simply cannot get this kind of light from your on-camera flash if you use a plastic diffuser cup or other such device. This is because it will throw light forward onto your subject, and you will lose that directional quality.

What If . . .?

Of course, the inevitable question is this: what if there is nothing to bounce your flash off? Well, then you adapt and do something else. But when there *are* surfaces to bounce flash off, this technique is repeatable and can give remarkably good results—results that look nothing like on-camera flash.

▼ The black foamie thing used to flag a flash.

20. BOUNCE FLASH FOR KIDS PORTRAITS

*N*ext, let me show you my favorite lighting setup to photograph kids indoors—with bounce flash!

At Home

Meet Jack. He's one year old. When Amy and Nick asked me to do a portrait session with him, we started off at their house. I wanted to grab a

TECH SPECS:

1/250 second, f/4.0, 800 ISO
Nikon D4
70–200mm f/2.8 VR II
On-camera TTL bounce flash

few candid photos of Jack happily playing before we set off to a nearby park. Since kids scoot around all over the place, it made the most sense just to use on-camera bounce flash. It requires very minimal gear—only the speedlight on my camera.

Shooting in TTL mode meant the flash exposure was pretty much spot on every time, regardless of where Jack zipped around. I had my black foamie thing (see previous section) handy in case I needed to flag my flash.

For me, this way of lighting is the most effective and simple approach to use in this environment. Best of all, this technique is

▼ One of the final images from Jack's session.

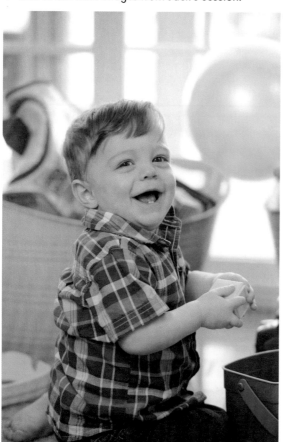

▼ The ambient-only exposure, for comparison.

▼ Stopping down didn't produce the background look I wanted.

accessible to any photographer working with a top-of-the-range speedlight.

The Background

I wanted the background to blow out, giving a light, airy feel to the photos. And of course, since I was using (bounce) flash against a much brighter (available light) background, shooting at the maximum flash sync speed made the most sense.

If I had changed my exposure settings so that more of the background showed (as shown in the image to the left, which was shot at f/11), the background would have been better exposed. With the change in aperture, the increased depth of field would also have made it more visible. However, since I didn't *want* the background to show, a wide-ish aperture made sense. The out-of-focus, overexposed haze is exactly what I wanted.

21. BOUNCE FLASH WITH A GEL

When photographing location portraits, a challenge that I have with myself is to look for options where there appear to be none—to work with what appear to be limited locations and then pull out something that is, hopefully, surprising.

▼ The existing light at the same exposure. You can see how much difference the bounce flash made.

▼ The lobby before we "decluttered" it.

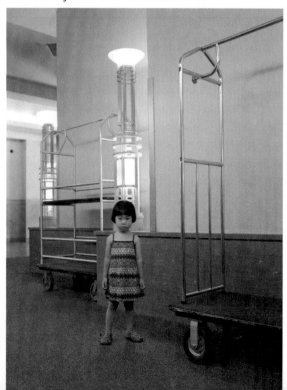

TECH SPECS:

1/250 second, f/1.4, 800 ISO
Nikon D4
85mm f/1.4G AF-S
On-camera TTL bounce flash

Location and Lens Selection

Before I went up to meet the family, I scouted the lobby of the apartment building where Penelope, a very cute two-year-old, lives with her parents. I liked the retro-cool decor of the huge lobby and thought it might make an interesting backdrop. Most people walking past wouldn't have glanced twice—but with a little tidying up and the right choices of lens, aperture, and lighting, I felt there was great potential.

Lens Selection

With a super-fast (short) telephoto, like the 85mm f/1.4, I knew the distracting background elements would melt away. Transforming the background into a complementary mush of colors and shapes makes it possible to shoot in surprising places.

Lighting

To clean up the light on Penelope, I used on-camera bounce flash (see section 19). Since the light there was a warm color because of the fluorescent lighting, similar in look to incandescent lighting, I fitted my flash with a ½ CTS gel. This brought my flash's color balance in line with that existing ambient light (see section 18).

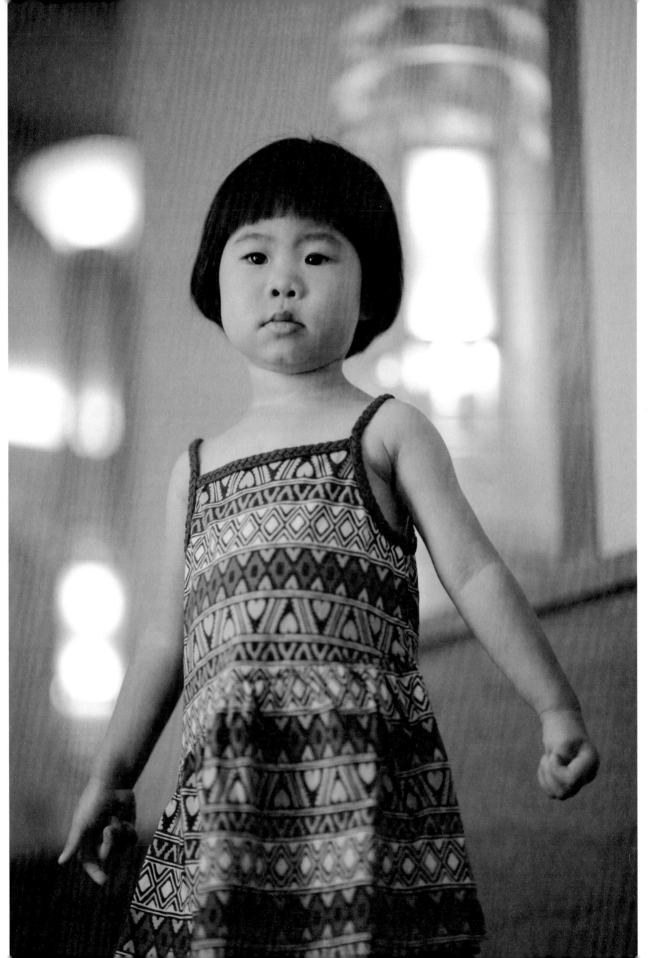

22. **SPEEDLIGHTS WITH GRIDS**

*F*lash diffused with an umbrella, or flash when bounced, spreads out and tends to light the entire scene with a flood of light. Even with a softbox, the light isn't controlled in how it spills. During this photo session with Austin, I wanted to get a spotlight effect, similar to that of a video light.

A Dramatic Look

For dramatic lighting, I really like the look of a video light, which produces well-defined shadows and nice falloff as the light spreads away from the subject.

Grids are light modifiers that also control the spread of a light's beam; often, however, this effect is too hard and concentrated. One of the speedlight modifiers I use, the Spinlight 360, has two grids—white and black. Instead of a video light, I tried the white grid to see if it would sufficiently scatter the light to "defocus" the light beam from the speedlight, while the grid itself contained the light. And here's the result

The SpinLight 360® GRIDS

◀ More info about the Spinlight 360 at: neilvn.com/ tangents/about/ spinlight-360

(*facing page*)—a look similar to that of video light, but with more power.

Using the PocketWizard TT5 wireless flash trigger on my camera, I could control the output. For this photograph, I also gelled the flash with a ½ CTS gel to bring the flash's color balance closer to that of the ambient light.

The result looks dramatic because of that central hot spot, but it was still flattering enough because of the position of the light and how his face was turned toward the light.

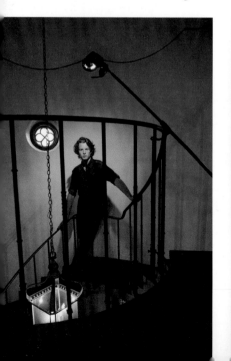

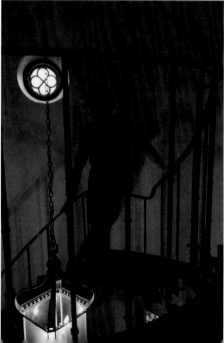

TECH SPECS:

1/60 second, f/4, 800 ISO
Nikon D4
Nikon 24–70mm f/2.8
Manual off-camera flash

◀ *(left)* The pull-back shot shows how the flash was positioned. Without an assistant there, I simply fastened the monopod to the rail with gaffers tape.

◀ *(right)* The ambient light levels without flash.

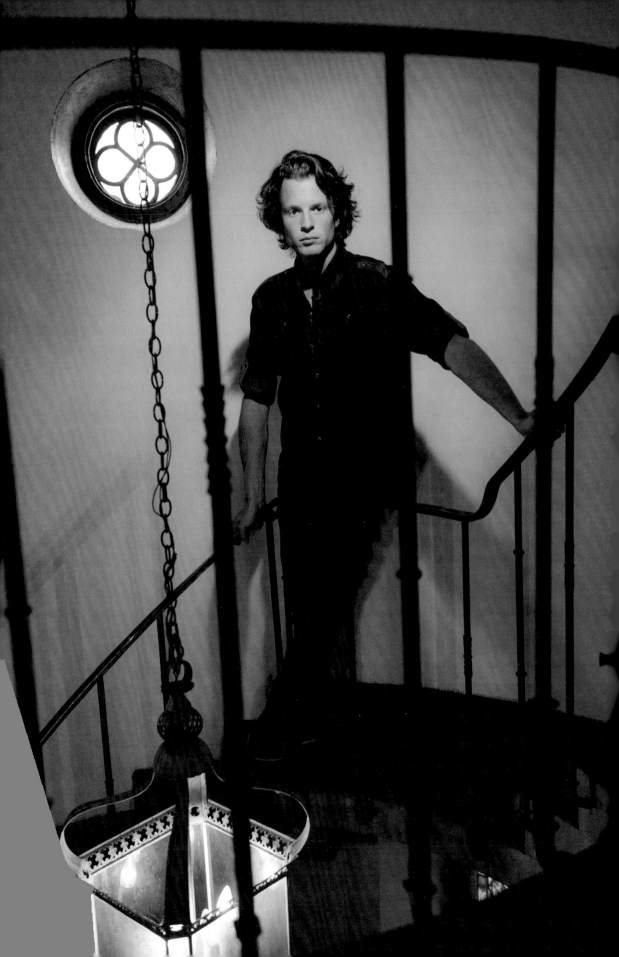

23. **FRESNEL LIGHTS**

*F*or my portraits of boudoir photographers Jennifer Rozenbaum, I wanted to show her in the studio where she works—the "office," as it were, of the boudoir photographer. While I didn't want to photograph Jennifer in a boudoir style, I wanted the images to be sexy (even a little feral) but also sweet—and very much *her*.

The Location

Our first image (*top left*) shows the daylight studio where Jennifer photographs her clients. It is flooded with light. While this flatteringly soft, low-contrast light is great for boudoir images, it just didn't have enough drama for my taste.

Lighting

I decided to use continuous lights—in this case, the Sola 4 LED Fresnel lights by Litepanels. These Fresnel lights allow you to get the same kind of dramatic light as the old Hollywood masters (such as George Hurrell, C. S. Bull, and Laszlo Willinger) with specific use of light and shade.

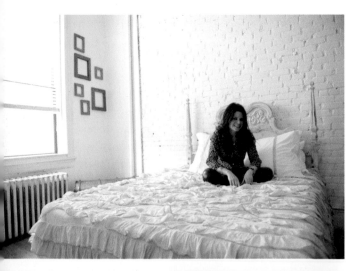

I wanted a hot spot behind Jennifer to help separate her from what would have been a darker background.

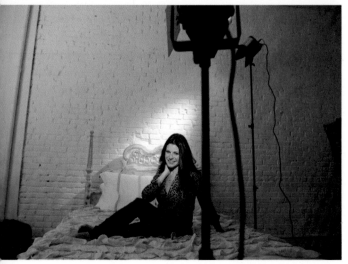

A benefit of shooting with video lights, and other continuous light sources, is that they are WYSIWYG (what you see is what you get). This means you can see the effect of the light on your subject as you adjust its position and your model's pose. You can closely observe exactly how the light falls across your model's features and make fine adjustments. Then it's a matter of adjusting the light levels, the focus of the light beams, and the position of your model to get the exact effect you want.

For the portraits on the facing page, the two Fresnel lights were set up as shown in the pull-

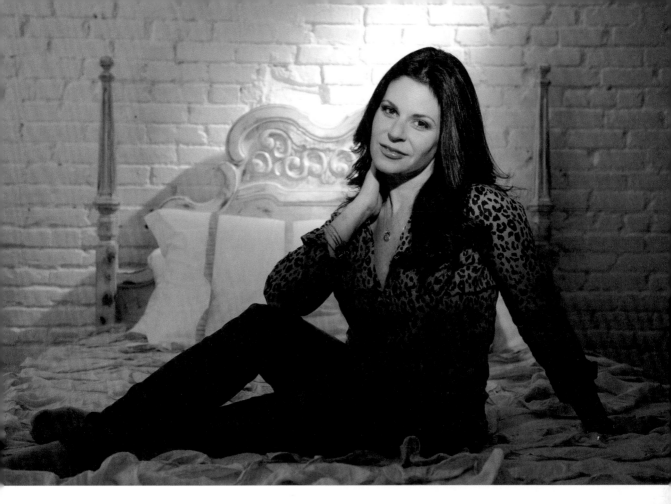

back shot (*facing page, bottom left*). I wanted a hot spot behind Jennifer to help separate her from what would have become a darker background. This splash of light in the background also implies a spotlight on Jennifer.

The main light was then focused on Jennifer, to light her face more.

Posing

We shot extended sequences, including images where Jennifer flipped her hair. This led to a lot of laughter but few usable images.

The portrait above is my favorite. It has a dynamic composition; the angles of her arms and legs form a pyramid with Jennifer's spotlit face at the apex. I also liked her slightly haughty expression in the image to the right, but the composition wasn't quite as dynamic.

TECH SPECS:

1/200 second, f/3.5, 800 ISO
Nikon D4
24–70mm f/2.8
Two Fresnel LED lights

24. WINDOW LIGHT BABY PORTRAITS

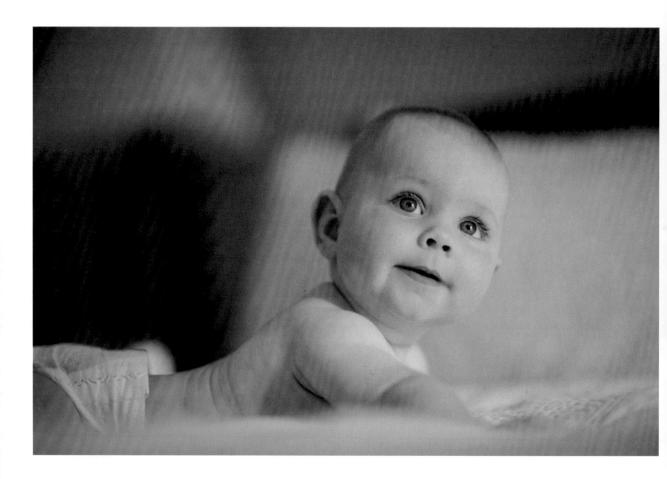

Any parent will tell you that each kiddo has a distinct personality from the moment it is born. For the photographer, then, the ideal is to capture some of this personality in the child's portraits. In this case, Liam's indomitable spirit as he tried to sit up made for hilarious expressions.

A Simplified Look

My own take on photographing babies is that I forgo all the props and accoutrements you often

TECH SPECS:

1/500 second, f/1.6, 1250 ISO
Nikon D4
85mm f/1.4G AF-S
Available light

see associated with baby photography—the hats and such. While using toys as props is often necessary to keep the child's attention, I still prefer to photograph just the baby.

Directing the Gaze

Liam's parents were close by, getting his attention. If anyone is going to call to the child, I prefer that they do it from right over my shoulder—nearly breathing down my neck. (Snapping fingers and pointing where the child should look never works.) I want the baby to look more or less towards the camera, so the "attention getting" person needs to be hovering right behind me. Of course, a baby's attention span is still very short, so you also have to work quickly and make the most of the baby's peak attentiveness.

closer to the camera needs to be pin sharp. (But, of course, the emotional content overrides specific technical perfection sometimes.)

Lighting and Perspective

The pull-back shot (*top right*) shows where we worked—in Liam's parents' bedroom, which has a huge window. These images were shot with only the available light. I made sure that the child's face was turned toward the light for clean, open lighting without hard shadows.

I also chose to shoot from a lower viewpoint, kneeling at the edge of the bed. This was an important factor in making this tiny baby dominant in the frame.

Another way I kept the viewer's attention focused on just the child was by working with an 85mm f/1.4 lens. An f/1.8 aperture would give you a very similar look. This shallow depth of field makes it challenging to get the focus exactly right. Ideally, the eye

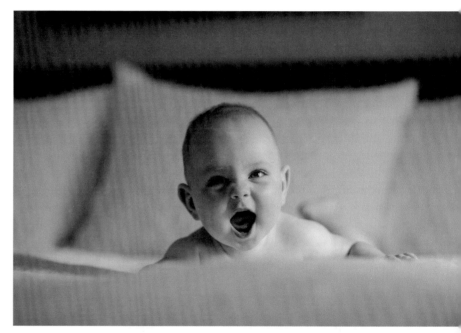

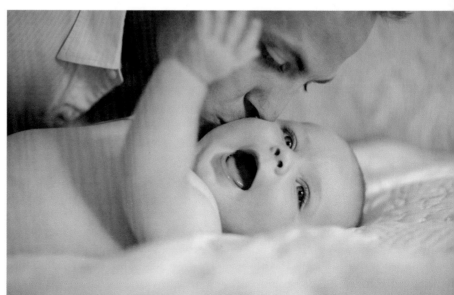

25. AVAILABLE LIGHT ENVIRONMENTAL

The subject of this portrait, John, collects vintage . . . oh, everything. His entire house is filled with collectibles—it is like stepping out of a time-machine into a different era. I joked with him that the only two things in his house from the 21st century were his fridge and his dog!

In His Workshop

Most impressive, in a way, is John's workshop where he maintains his two vintage motorbikes and a Model A Ford. The tools in his workshop are all authentic to the era—and they work. The way John describes it, it actually makes sense in the way he maintains everything with hand tools and lathes and such.

I wanted to portray him amidst all the items. I also wanted to stay true to the spirit of what was presented, so I just used the available light. Sweeping the garage doors open produced a flood of soft, directional light—perfect.

> **TECH SPECS:**
> 1/160 second, f/2.0, 800 ISO
> Nikon D4
> 35mm f/1.4G AF-S
> Available light

▼ Shooting at an angle to the open garage door produced a dynamic interplay between light and shade. Just wonderful.

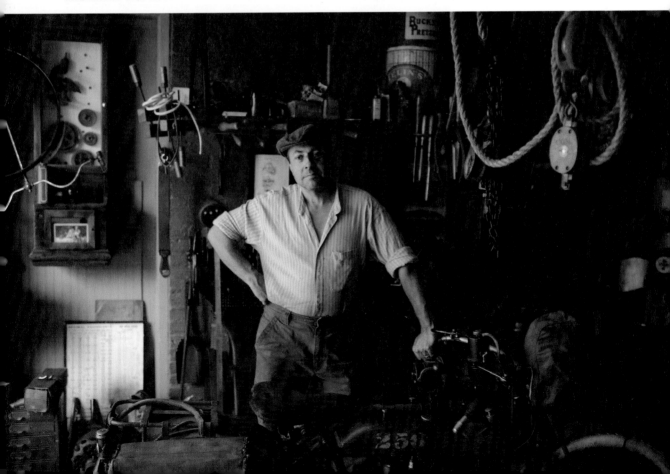

chose specific places to shoot and specific shooting techniques—always aware of the light falling on my subject and the scene.

As an aside, note that John also affected a "strong man" pose, which was perfectly reminiscent of a previous era.

I chose specific places to shoot and specific shooting techniques – always aware of the light falling on my subject and the scene.

Deeper Into the Workshop

I also wanted to shoot deeper into the workshop (*above*). Here's an interesting trick—or observation, if you will.

Check out the two photos to the right. They are quite similar, except that in the first one (*top right*), John was further back into the workshop. Therefore about the same amount of light reached him as that which fell on the tools and workbenches behind him.

For the second image (*bottom right*), he stepped forward to help me demonstrate a point. He was now much closer to the open garage door. Getting a correct exposure for him now (more brightly lit by the available light) meant the background was comparatively much darker. I would have needed to added lighting on it to pick that area up to the proper exposure level again.

While adding a light behind him as backlighting would have worked, I wanted to keep it natural. So with this in mind, I

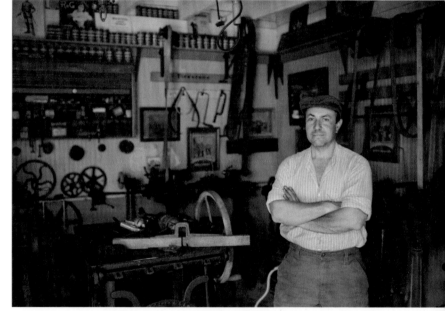

26. VIDEO LIGHT FOR LOW-LIGHT DRAMA

When working at a low-light location where the atmosphere of the place is important, I often use video lighting. Unless you're working with a small gridded softbox, flash tends to open up the background too much. When photographing model Megan Daniel at a St. Louis photography convention held in the Union Station Hotel, I wanted to keep that late-night, cavernous feel.

Lighting

Video light tends to have rapid light falloff because the light is more contained and also because you tend to work closer to your subject with the light. That dramatic quality of video light is what I use to enhance the look of portraits in low-light environments.

With some LED video lights you're able to continuously change the color balance from

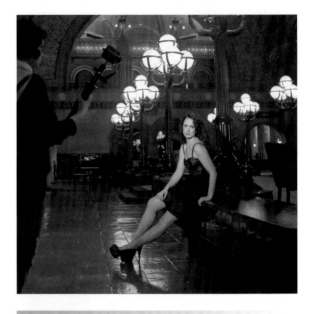

TECH SPECS:

1/30 second, f/4, 1600 ISO
Nikon D4
24–120mm f/4G VR
LED video light

incandescent to daylight. This is a really nice feature because you can now more closely match the additional light to the existing ambient light.

The lighting here in this hotel lobby was incandescent—or close enough. By using my video light at a white balance to match this, I was able to make all the colors appear "normal," so I didn't have to deal with skin tones that were too blue or too yellow.

The pull-back shot (*above*) shows the position of the video light, held up on a monopod by an assistant. I used a vibration-reduction (image stabilization) lens for this shot, which helped offset the slow shutter speed.

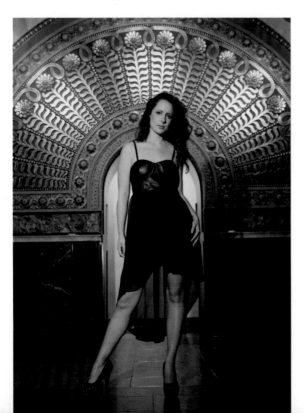

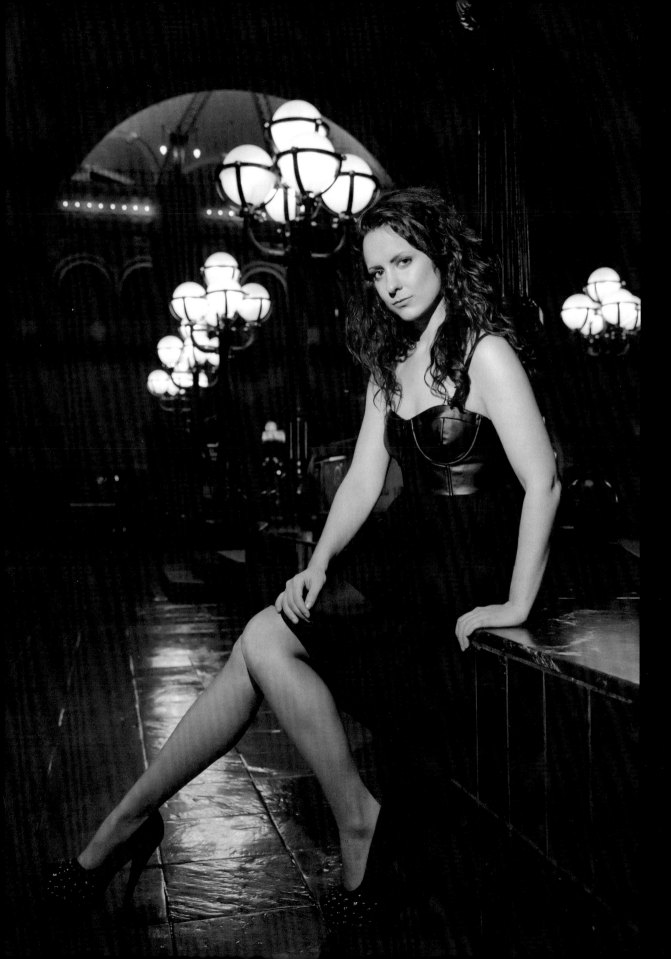

27. WEDDINGS WITH VIDEO LIGHT

The image below is one of my favorite photos of Julia and Luis's wedding. Why can't wedding portraits of the bride and groom be a little bit sexy?

Video Lights

Video light is, for me, an essential part of my lighting arsenal when I photograph weddings. The harder light and its rapid falloff lend a certain dramatic quality to my images.

A video light like the Lowel ID-Light, which was used here, is balanced for the incandescent lighting found in most indoor locations. The color balance is usually easily matched. An LED video light such as the Litepanels Croma makes it even easier by allowing you to change the color balance to your own intent.

TECH SPECS:

1/100 second, f/4, 1600 ISO
Nikon D4
Nikon 24–70mm f/2.8
LED video light

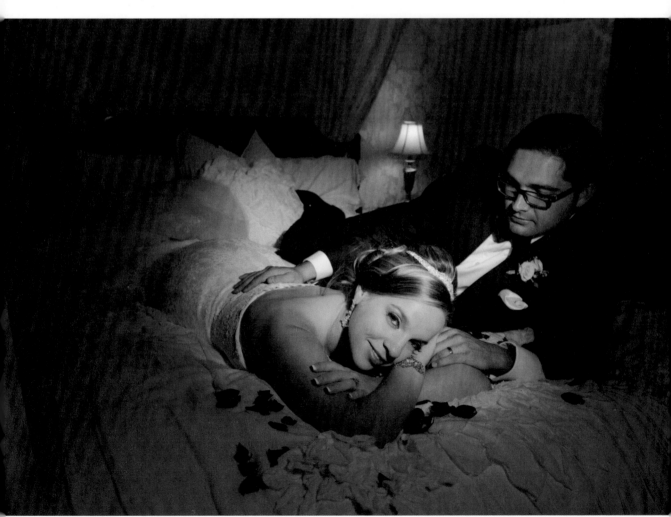

You have to be quite particular about how you position the video light in relation to your subject's face.

Positioning the Light

A video light is so easy to use in one sense but tough in another. The WYSIWYG nature of video light means you can easily adjust its power and position. However, since it is a small light source, you have to be quite particular about how you position the video light in relation to your subject's face. Check for weird and unflattering shadows. In particular, study how the shadow of the nose falls and if the eyes are shrouded in shadow. The pull-back shot (*above*) shows the placement of the light for this couple.

Postproduction

For both of these images, I lifted the shadow areas during the postproduction of the RAW file. I used the local corrections brush in Lightroom to bring up some additional detail in these parts of the portraits.

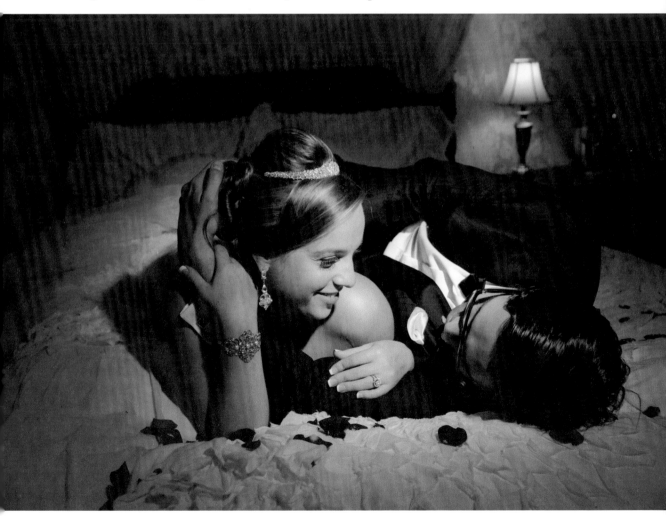

28. **POSING ENGAGEMENT PORTRAITS**

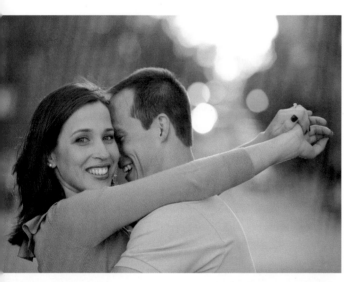

I love doing engagement photo sessions because they allow me the opportunity to connect with my clients before their big day. Even more so, I love that there's much less pressure and haste during this photo session than during the wedding day.

The Essence of Their Relationship

Although I often pose and direct the couple during their engagement photo session, it is still imperative to capture their real relationship. It really is all about them and how they are with each other. Try to photograph the essence of that—the spark, the way they interact.

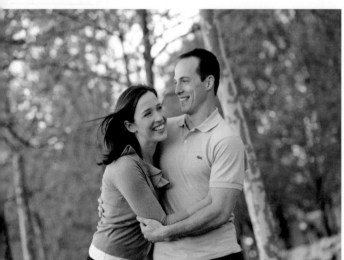

Keep It Loose

Most often, I start the posing very "loosely." I don't try to force anything that would make anyone physically uncomfortable. My advice is this: if it feels uncomfortable, it usually looks uncomfortable. I might get the couple into a basic pose, then ask them to talk to each other, give gentle kisses (no pouty-lip kisses!), or exchange gentle nuzzling. Talking to each other is a good place to start. They'll usually take it from there, and then you just have to guide them a little bit ("Don't tilt your head too much," etc.).

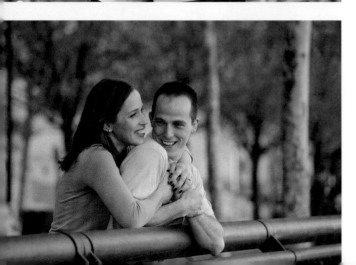

It really is all about them and how they are with each other. Try to photograph the essence of that–the spark, the way they interact.

Start with One Person

While the pose shown in the main photo (*below*) needed Melissa and Dennis to get into position simultaneously, my general advice for posing two people is to start by posing just one person. Have that person anchor the pose, then add the second person.

This is a simple arrangement, but it works—and the pose can always be adjusted in terms of how their hands are placed on each other's arms. Let them enjoy each other's company as you photograph their relationship.

Keep the Energy Up

Chat with your clients. Don't be too involved with the camera gear and lighting. It is imperative that you keep the energy going and keep their interest. The most obvious point of connection? Talk about their wedding day. Ask how their plans are coming along. Ask about the details. Keep it chatty. Be personable. Their experience of the photo session with you will be as important as the actual photos. Keep it fun.

TECH SPECS:

1/100 second, f/5.6, 800 ISO
Nikon D3
Nikon 24–70mm f/2.8
Late-afternoon available light under a tree

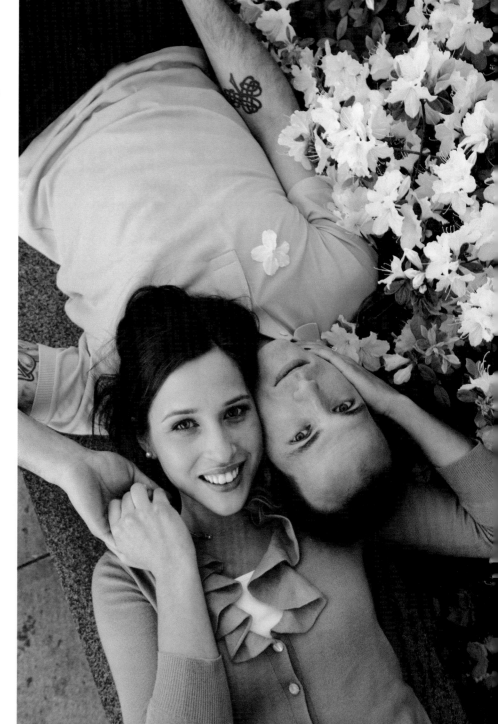

29. COMPOSITION AND FOCAL LENGTH

*H*ere's a technique that I strongly recommend: when shooting portraits with a zoom lens, step back instead of just zooming wider. The perspective distortion that a wide-angle lens will cause is not all that flattering to your subject.

A Close View

For this straight-forward portrait of Anelisa (*below*), I was shooting with the 24–70mm lens (on a full-frame camera) zoomed to 70mm. I wasn't super tight in my composition, so I was

shooting at a distance where there is no perspective distortion introduced on her face. (For example, a 50mm lens used as a close portrait lens on a full-frame camera will bring unfortunate distortion to your subject's face.)

Going to Full Length

If I wanted to shoot a full-length portrait now, I have two options:

1. I can zoom wider (without changing my camera position) to get all of Anelisa in my frame, or
2. I can keep my lens at 70mm and step back until I have her full-length figure in my frame.

Zooming wider and tilting the lens slightly down produces the kind of bobble-head distortion seen in our first full-length image (*facing page, bottom left*), where her head is much larger and her legs are much shorter. This is definitely *not* a flattering look. Stepping back (*facing page, bottom right*) forces a more pleasant perspective.

So when photographing someone, I fight the immediate urge to be lazy and just zoom. Instead, I keep to the longest focal length (as much as I can) and step back until I get the framing I want. Invariably, this longer focal length gives the more flattering perspective.

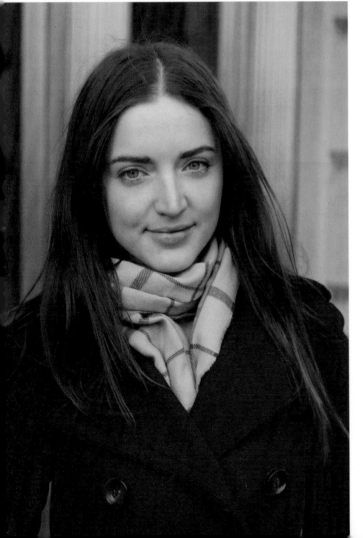

◀ A close view of Anelisa photographed at 70mm shows no distortion.

Only when I can't safely or comfortably step back anymore will I zoom wider. But my focal length then will still be more appropriate than if I had immediately racked my zoom as wide as I could from the start. To give you an idea of the relative distances, see the images below.

Are There Exceptions?

Obviously there will be times when you want a more dynamic composition, or you may *want* to go for the crazy wide-angle shot. But for a representative portrait, it is always the better decision to step back rather than being lazy and just zooming wider.

▼ Simply zooming wider (top) to go to a full-length view results in unflattering distortion (bottom).

▼ Stepping back for the same composition at a longer focal length (top) yields better results (bottom).

30. GESTURE AND CONNECTION

*W*ith portraits of a couple, the way they connect with each other is often the determining factor in whether the image is compelling. This connection could be through gesture and touch. The gesture might even be subtle. If a couple snuggles in, they don't have to look at each other; it's entirely possible to give that sense of connectedness with

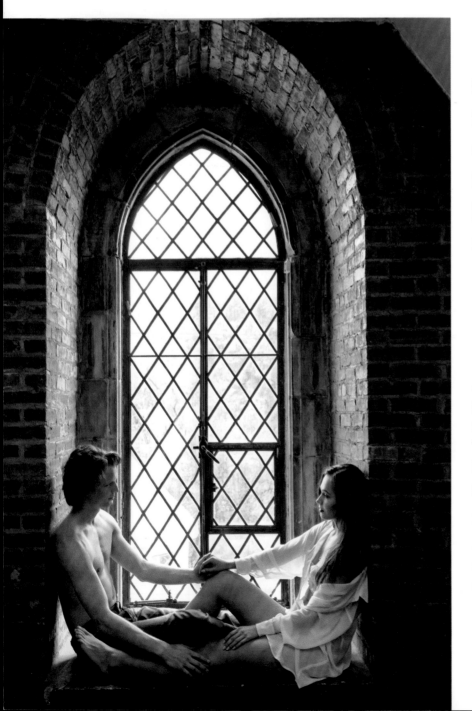

With portraits of a couple, the way they connect with each other is often the determining factor in whether the image is compelling.

◄ Olena and Austin are directly looking at each other, hands intertwined and legs touching. The connection is clearly there. Here, the couple was photographed using window light only.

TECH SPECS:

1/160 second, f/4, 800 ISO
Nikon D4
Nikon 24–70mm f/2.8
Window light

▲ ▶ For the three images with Olena leaning into Austin, I added a speedlight in a gridded softbox.

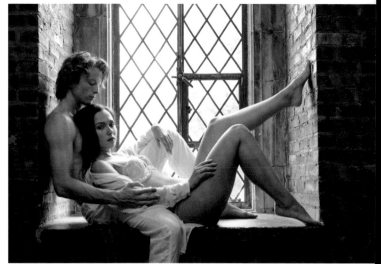

even a downward glance. As long a it looks like they are concentrating on each other or responding to each other, it works.

"Drop Your Gaze"

Compare the three images to the right. There's a definite sexiness that exudes from the couple, but only in the top image (where Austin's chin touches Olena's head) does the connection between them really kick in. He doesn't need to look directly at her for him to appear attentive—but when his gaze becomes totally distant, as in the middle image, the connection is lost. It just looks like he wants to be elsewhere. In the bottom image, the connection was somewhat regained. I had asked him to drop his gaze so he didn't appear to be looking away.

This instruction ("Just drop your gaze.") is one that I frequently use. It is somehow more clear to people than telling them to "look away" or "look down." The instruction to look somewhere is too specific, but telling them to change the direction of their gaze seems to be easily understood.

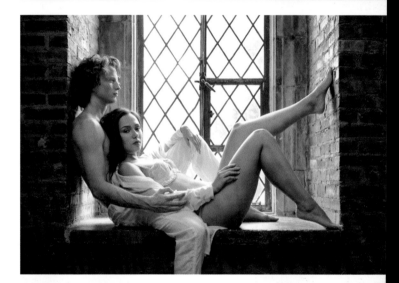

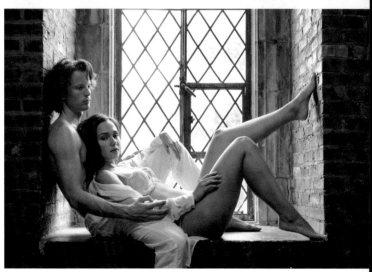

31. DRAMATIC STYLE WITH LED FRESNELS

*A*viva and Brian brought some spy-movie style to this photo session. The location was a hotel lobby with huge displays that are constantly changing colors. The challenge was to retain this certain "noir" mood and add a touch of sexiness.

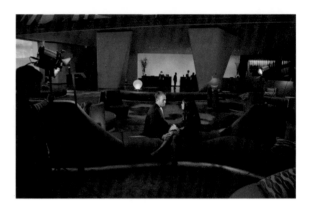

Lighting

I used LED Fresnel lights, a modern version of the hotlights used for classic Hollywood glamor lighting. The specific make was the Litepanels Sola 4. The 4-inch diameter Fresnel gives a fairly concentrated beam that can be focused, dimmed, and of course flagged. I added one light on Aviva and another on Brian, but more as sidelight/backlight. Both were flagged to control the spread of the light. The pull-back shot (*above*) shows the setup.

When lighting a couple, I tend to favor flattering light on the woman. This is an important consideration when posing—and when adjusting the light as the poses change.

Background Selection

When deciding on this particular background, I sat down in each spot to feel if the pose made

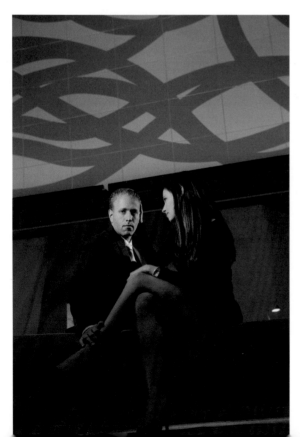

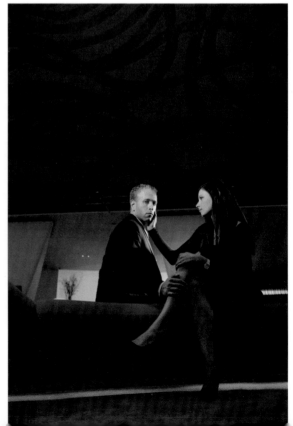

sense and to figure out the lights. I did all of this before positioning the couple. Then, when it seemed the idea would work and the lights were set up, I added the couple and finessed the pose and the lighting.

While I generally tend to loosely pose people (as mentioned in section 28), in this case I had to be more meticulous with watching how Aviva placed her hands. Brian's hand on her leg also had to be purposefully positioned; I didn't want it to look like a casual afterthought.

The reason for this extra posing precision was, in part, the lighting. With smaller light sources like these Fresnel lights, the light tends to be harder and more contrasty. Slight changes in how someone holds their head can make or break the image. The nose's shadow descending down over the top lip, or the eyes deeply shrouded in shade, can easily make an image fail.

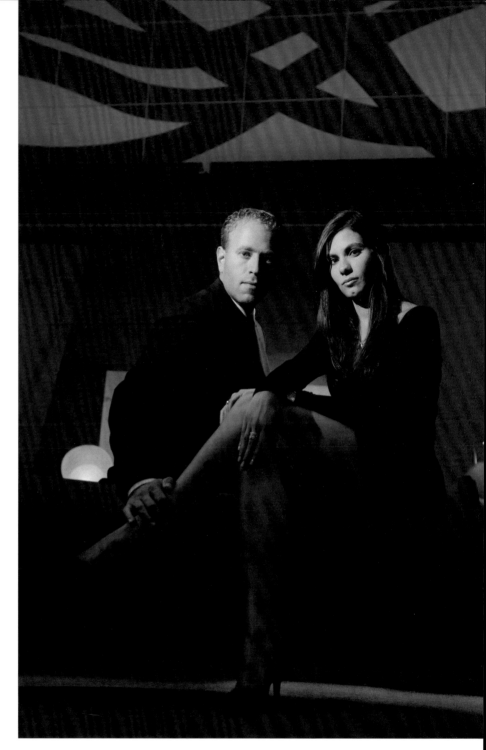

I had to be quite specific with every gesture of posing my subjects. When positioning someone's head, I most often use large, slow gestures with my hands to indicate what I want. I also use my own body to mirror what I want them to do.

TECH SPECS:

1/100 second, f/4, 1000 ISO
Nikon D4
Nikon 24–70mm f/2.8
Two LED Fresnel lights

32. SEIZE THE OPPORTUNITY

When we discover a location that is intriguing and looks like it might offer more opportunities, it makes sense to revisit it and see what other inspiration might strike. The challenge is not just re-creating our past ways of shooting there but finding something new and fresh.

This large sundial in Jersey City just draws you closer to have a look—and even clamber over it. I've been here before (and I used this image in my book on off-camera flash), but this was a different day, with a different model, different equipment, and different lighting. So it came together in a different way.

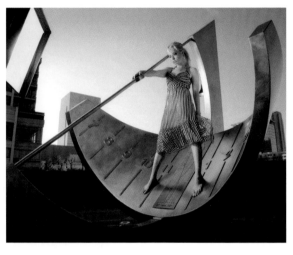

▲ A different image concept created during another session at the same site.

Lighting and Exposure

The light on Nicole is from the metallic sundial below her, reflecting light upward. With the curve of the sundial, the light hits her from every direction. This photograph was shot at f/1.4 in very bright light. The shutter speed had to be $^1/_{8000}$ second (at 100 ISO) to allow such shallow depth of field. I really wanted attention focused on Nicole.

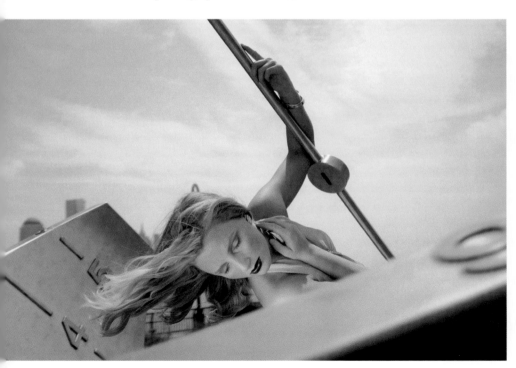

Different Sensor Size, Different Look

Interestingly enough, this image was shot with the Fuji X100s, which has an equivalent focal length of 35mm. With the smaller sensor and a maximum aperture of f/2, the depth of field looks quite different from that in the image (shot with the Nikon D4) on the facing page.

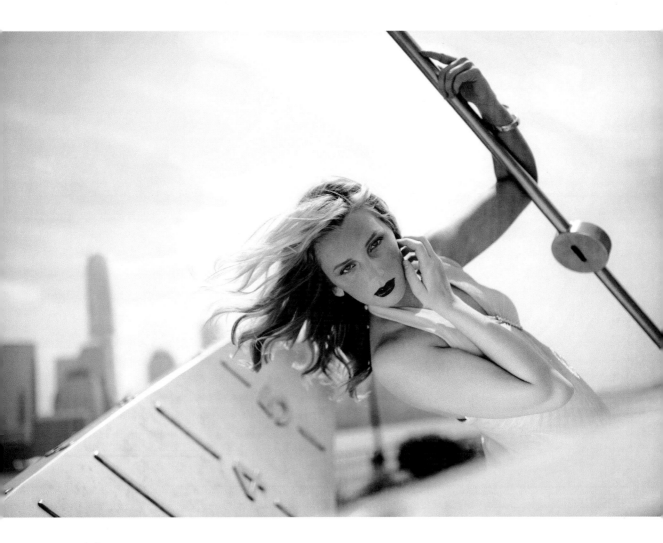

Composition

The strong diagonals are what make the composition of this image so striking. With the sundial's edges and the needle at these angles, I asked Nicole to hang from the needle with her one arm. (The needle is what casts the shadow by which time is indicated on the sundial.) I then directed her pose so that her arms were parallel to the needle, all to accentuate the lines. A gust of wind caught her hair and completed the series of triangles here.

TECH SPECS:

1/8000 second, f/1.4, 100 ISO
Nikon D4
Nikon 35mm f/1.4
Available light

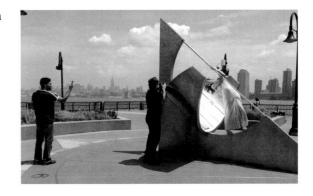

33. FINESSE

*I*t's wonderful keeping in touch with previous wedding clients like Renee and David. Over the years, it's great seeing them for photo sessions—this time with their daughters, Olivia and Julia.

Flash Plus Ambient

Looking at the images to the left and the setup shot below, the technique should be easy to decipher. I used off-camera flash in a softbox and shot with a longer lens to compress the perspective. I posed the family (and the two kids, in the lower image) with the sun behind them to give some rim lighting. The flash was set to manual exposure mode, since my subjects were going to remain at a specific distance from the light.

TECH SPECS:

1/250 second, f/3.2, 200 ISO
Nikon D4
Nikon 70–200mm f/2.8 VR II
One manual flash in a softbox

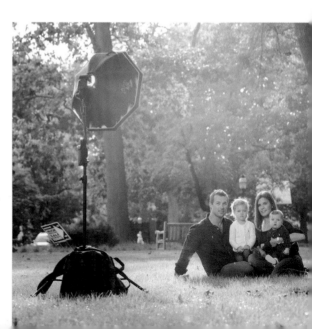

Ambient Only

The images to the right were shot as I was still setting up. I had David get in position with Olivia so I could determine my camera and flash settings. At this point, I was still getting my ambient exposure and hadn't enabled the flash yet. But there was this magical moment between a dad and daughter, so I kept shooting. In the image of Olivia alone, I love the touch of lens flare that creates a vignette of color around her.

Lens Selection

Another wonderful thing about using a long lens is that you're at a distance, which makes it much easier to get these natural moments. Work too close to the kids and you can easily become a distraction. Of course, depending on how you work with kids, and your own personality, it might be to your advantage to interact with them. Personally, I prefer to be further back—a big guy with a big lens isn't easy to ignore close up!

TECH SPECS:

1/500 second, f/3.2, 800 ISO
Nikon D4
Nikon 70-200mm f/2.8 VR II
Available light

34. **A BETTER PERSPECTIVE**

*I*t's a bit of a cliché, perhaps, seeing a photographer lying on his side or sprawled on the ground. However, what might look like a strange form of attention-seeking is actually a very solid way of improving your composition with full-length portraits.

Avoid Distortion

The lazy temptation is to just stand there, camera to the eye, and take the photo. What happens then (usually) is that the photographer is shooting *down* on the subject. The best advice, generally, is to step back for full-length compositions (as described in section 29). When you shoot down on someone, especially with a wider angle lens, the perspective distortion causes the feet to appear much smaller and your subject's head to appear disproportionately large.

A Better View of the Background

With a longer focal length, such as was used in this outdoor portrait of Elle, perspective distortion is less of a concern. The lens was zoomed to around 135mm so her head and feet were equidistant to the camera—meaning no distortion. However, if you take the photo just standing at your full height, then you are still shooting down and you're getting far too

▼ Camera at standing height.

▼ Camera at kneeling height.

much of the ground in the image. The path here behind Elle isn't awful, and doesn't distract. But it's the colors behind her that help make this image pop, complementing the colors of her clothing.

Below is a series of three images, shot while I was standing up, kneeling down, and finally, lying flat on the ground. Notice how the background changes as my perspective changes. Eliminating much of the ground gave this straight-forward portrait of Elle more impact.

This is something I always check for when photographing someone—whether I can tighten the composition by shooting from a lower angle. Even a slightly lower angle eliminated most of the pathway here.

Lighting

To augment the light, I added just a touch of fill flash with a speedlight in a softbox to give

▼ Camera at lying-down height.

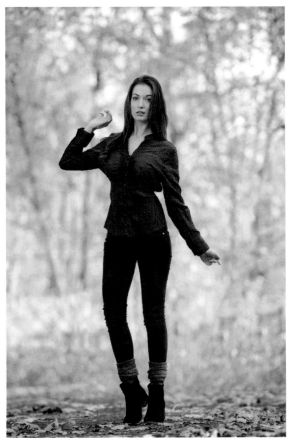

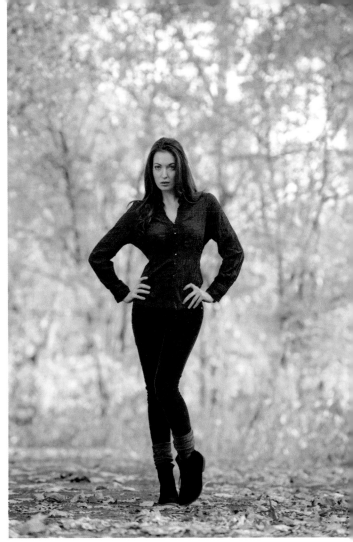

▲ Another pose shot from a low angle.

TECH SPECS:

1/250 second, f/3.5, 200 ISO
Nikon D4
Nikon 70–200mm f/2.8
Manual off-camera fill flash

flattering light on her. Notice that shaded area on the ground near her feet? I specifically posed her there so that there would be no dappled light on her. Decisions like these are very much part of the lighting technique involved in location photo sessions. You have to pick your battles!

35. RULES OF COMPOSITION

*I*f a photograph is intended for an audience, not just my own records and memories, I think its success hinges on impact. Does the photo make you stop for at least a few seconds to take it in? If it does, you're at least partly successful already. With portraits, so many elements kick in to give a photograph impact—the moment, the expression, the gesture, the movement, the pose and position, the lighting, and more.

An Instinctive Approach

In terms of composition, I strongly feel that photographers should react in an instinctive way. Look at the subject and scene and respond without the mechanical decision-making that all the rules of composition (the Rule of Thirds,

▼ The ambient light was about 2 stops underexposed.

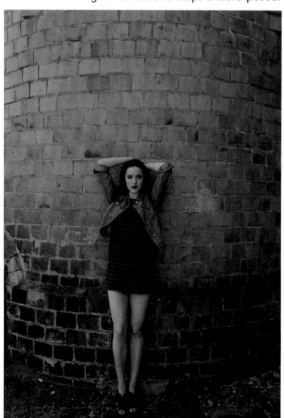

> **"There are no rules for good photographs, there are only good photographs."**
> — *Ansel Adams*

diagonals, mathematical formulae, the Golden Mean, etc.) bring into play.

Instead, take your time to look at what is actually presented in the viewfinder. Scan the whole frame; look at the sides and corners. Is everything that you *see* everything that you *want*? Is this the best way that the subject can be represented? Do you need to re-frame or move to another position?

In terms of composition, I strongly feel that photographers should react in an instinctive way.

Looking at This Image

The composition of this photograph of Anelisa (*facing page*) can be analyzed in terms of the usual guidelines:

- The negative space above her,
- The diagonal line implied by her arms,
- The sense of balance produced by the S-curve in her pose, and
- The vertical line created by her body being off-center in the frame.

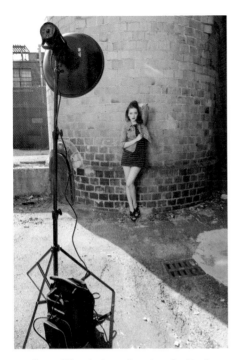

▲ The pull-back shot, showing the Profoto D1 Air 500Ws monolight. The Profoto beauty dish was the main light on Anelisa.

▶ The final image.

TECH SPECS:

1/250 second, f/5.6, 200 ISO
Nikon D4
Nikon 24–70mm f/2.8
Off-camera flash with a beauty dish

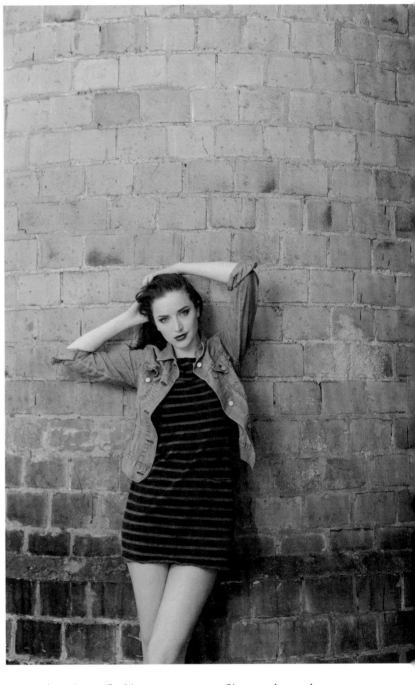

There is also the strong visual dynamic created by her face being more or less central to the frame—as well as the curve of this industrial chimney structure, which pulls your eye toward the center.

All these things do appear when you begin analyzing the image after the fact. But during the time of taking a sequence of images here, the decision wasn't step-by-step like that. It was much more that instinctive recognition that, "Hey—this looks good!"

36. **THE 85MM F/1.4 LENS**

Too Much Light

The super-wide aperture of the 85mm f/1.4 lens presents a few challenges—the obvious one being that the shallow depth of field isn't forgiving of even the slightest movement. Working with studio lights, though, another challenge is that sometimes there's just too much light. In the next example (section 37) where I shot with a similarly shallow depth of field in a (home) studio setup, it was with speedlights. That made it easier to get to the f/1.4 aperture.

Lighting Setup

For these images, the main light was a Profoto 5 Octa Softbox. This huge light source makes it easy to get flattering light. By moving it in a semi-arc around your subject you can control the contrast and how much light falls on the shadow side of your subject's face. This makes it quite flexible for a single light source.

The rim light was a Profoto 1x3-foot softbox with a softgrid to control the light. This rim light helped create some separation from the background.

The light on the wall used as the background was gridded to give a slight hotspot behind her. I didn't want an evenly lit background.

Reducing the Light

With the 500Ws monolights, there was just too much light—but I wanted to use that huge Profoto 5.0 Octa Softbox because of how easy it is to control. So I had to use a 3 stop neutral density filter to bring the light down.

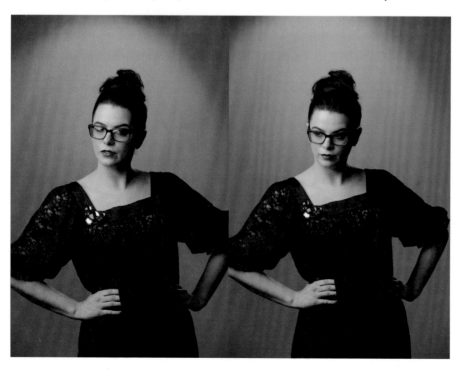

◀ The issue of eyeglass reflection was handled simply by adjusting Oktavia's pose, as shown in these images.

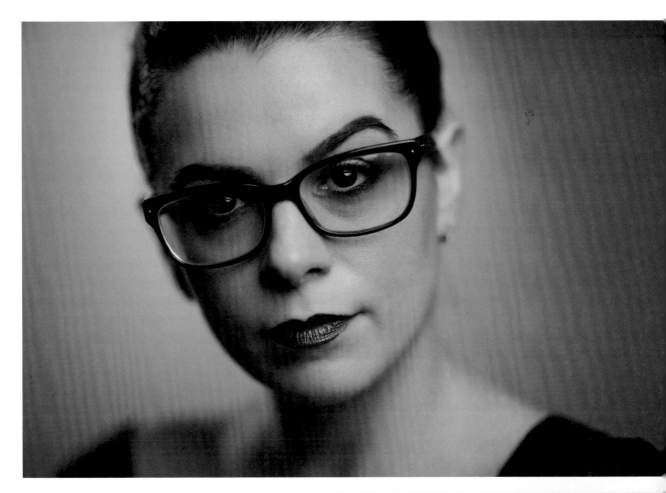

TECH SPECS:

1/160 second, f/1.4, 100 ISO
Nikon D4
Nikon 85mm f/1.4G AF-S
B+W 77mm 0.9 (3 stop) ND MRC 110M filter

This produced another problem: the camera just didn't want to grab focus in such low light while a 3-stop ND filter was on the lens.

I ended up having the makeup artist hold a video light closer to the model so the camera had enough light to focus. Then I'd take a sequence of photos while the video light was pulled away. It's not an ideal way of working. This look is actually much easier to pull off with speedlights or smaller flashes, as we'll see in section 37.

37. **A HOME-STUDIO SETUP**

Shallow Depth of Field

In a studio, we usually work with apertures in the range of f/8 or f/11 for great depth of field and superb image sharpness. However, shooting portraits with fast lenses for that distinctive shallow depth-of-field look also works in the studio—in fact, it works exceptionally well. That super-fast-aperture portrait lens really focuses the attention exactly where you want it. With portraits, that's almost always your subject's eye that is closer to the camera.

Studio Lights *vs.* Speedlights

Unfortunately, as we saw in section 36, higher-powered studio lights can produce too much light. This is where working with lower-powered speedlights is an advantage. With speedlights,

TECH SPECS:

1/200 second, f/1.4, 100 ISO
Nikon D700
Nikon 85mm f/1.4G AF-S
Two Quantum T2 units, one Nikon SB-800

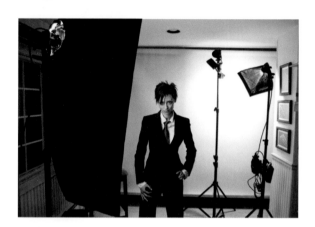

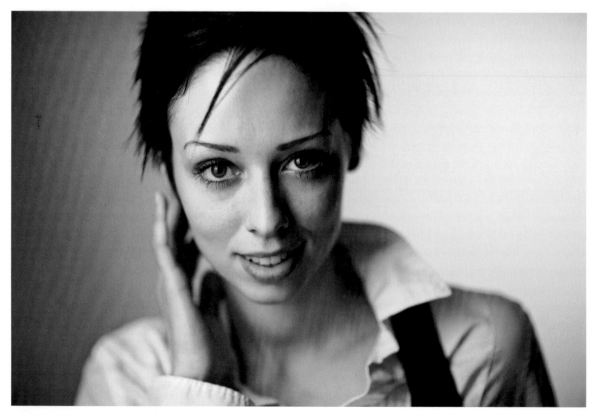

that super-thin depth of field is more easily attained—without having to deal with neutral density filters.

In My Dining Room

The photos of Kaylex were shot with a fairly simple lighting setup in my dining room area—a makeshift home studio. The pull-back (*facing page, top*) shows you just how unglamorous and cramped it actually was. Yet the final portraits looked great.

The main light to camera left was an 18x42-inch strip bank. The flashgun was a Quantum T2, but a speedlight would have worked just as well. In this small space, you don't need huge amounts of light.

I used another Quantum T2 to light up the gray seamless background. I had a 12×12-inch softbox on this one and feathered it to give me uneven lighting on the backdrop. I also had a snooted Nikon SB-800 as a hair light in most shots.

For the image shot at f/1.4 (*facing page, bottom*), the power on the Q-flash was turned down to $\frac{1}{32}$ or $\frac{1}{64}$, for just a touch of light.

Different Lens, Different Look

For the images on this page, I used a 70–200mm f/2.8 lens (on the Canon 1D Mark II) at more usual apertures ranging from f/5.6 to f/8 with the same lighting setup. As you can see, studio lighting can be done (or at least approximated) in a home studio.

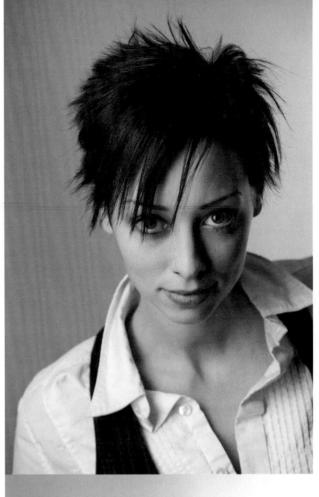

38. STUDIO HEADSHOTS

*M*ike is an actor/musician friend of mine who needed his portfolio updated. We started off with headshots in the studio. Because Mike is a character actor, we took many photos in which the expressions were quite goofy and strange. Here's a small selection of his headshots, which show some character and expression.

Background

The background was the back wall of my studio, which is painted a light gray. Because of light falloff, the background appears dark gray in the final images.

Lighting

The lighting setup for these images was fairly simple. I wanted clean, open light on him so you could clearly see his expressions. I also wanted a large light source so we had some freedom with his movement. However, I still wanted some contrast to the shadow side—but not too dark.

This relatively simple setup gave me the results I wanted for these headshots – but I do change it up . . .

I used two Profoto D1 Air 500Ws monolights for my lights, but the same lighting could be very easily approximated with speedlights and the necessary light modifiers.

The main light on him was diffused with a large Profoto 5 Octa Softbox. This massive octabox gives beautiful, soft light. I had it set to an angle, so it was feathered away from him

TECH SPECS:

1/160 second, f/11, 200 ISO
Nikon D4
Nikon 70–200mm f/2.8 VR II
Two Profoto D1 Air monolights, V-flat

a bit. There's a reason for that. If you feather a large light source, you can have your subject step forward for a more contrasty look. If you have them step back, then you get more of a soft wraparound effect to the light.

The fill light was via a white V-flat, which acted as a reflector. The V-flat consists of two white foam-core boards that are taped together with gaffers tape to form a V so it can stand upright. I set it up so that it reflected light from the front and side of my subject, and a little bit from behind. Just enough fill light for what I wanted. There's no exact science to it.

The hair light was via the second Profoto D1 Air 500Ws monolight, supported on a boom. The light beam was narrowed by a grid.

This relatively simple setup gave me the results I wanted for these headshots—but I do change it up at times, always exploring.

39. LOW-KEY VINTAGE PORTRAIT

Randy has a look reminiscent of Ava Gardner, so I wanted to create a portrait of her using the classic Hollywood glamour style of lighting.

Lighting

For this setup, I used a Profoto beauty dish as the single main light source. A beauty dish is best used with a grid to contain the light spill, making the light quite directional. This means that you have to pose your subject precisely. When using a beauty dish as the single main light, there's none of the free movement you

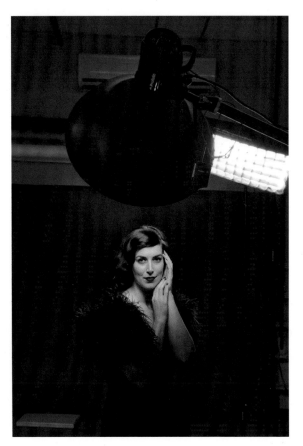

have when using large light sources and multiple lights in the studio. Even the slightest movement of your subject's face makes a big difference in how the shadows appear.

Without additional light from other sources to give fill light, a beauty dish can be fairly challenging as a single light source.

Background

I wanted a low-key look, so I used a dark gray backdrop and worked well away from it so that the main light had very little effect on it. The Inverse Square Law helps here with the non-linear light falloff to the background. In other words, the further the background is from your subject and light, the darker it will appear.

Separation

To prevent Randy's dark hair from melting away into a black background, I needed a hair light of some kind. I set up a gridded Profoto 1x3-foot softbox behind and above her.

The pull-back shot (*left*) shows where the gridded beauty dish was placed, as well as the position of the gridded 1x3-foot softbox behind Randy. Keep in mind that I pulled up the shadow detail for this photo, so that you could actually see the lighting gear here.

TECH SPECS:

1/200 second, f/8, 100 ISO
Nikon D4
Nikon 70–200mm f/2.8 VR II
Beauty dish with grid, softbox with grid

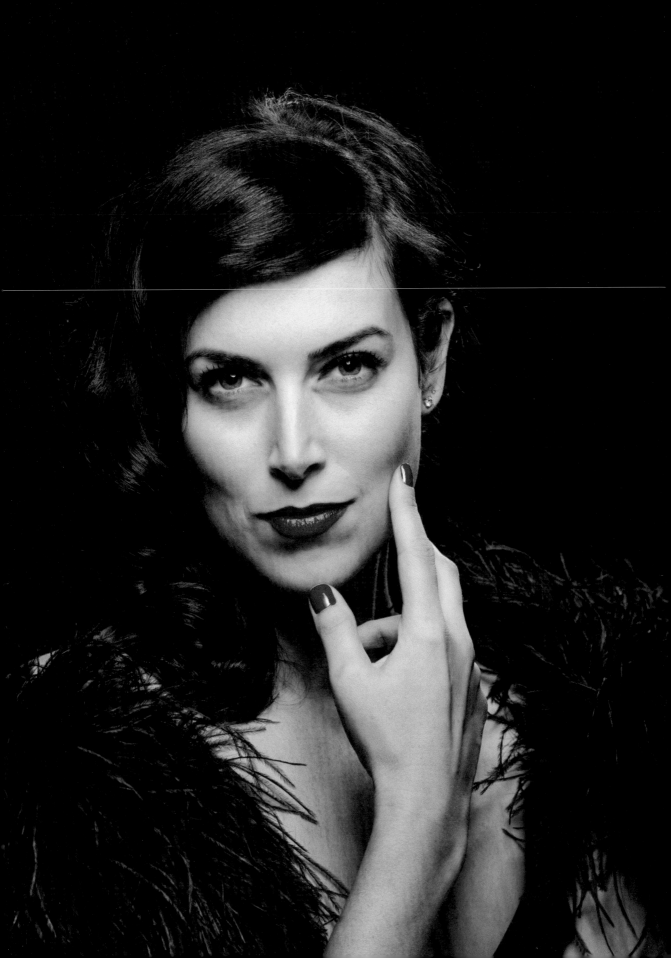

40. CONTINUOUS LIGHTS

This striking portrait of Lauraine shows her sparkling mischievousness—and, on the techie side, the selective focus of a fast lens paired with the flexibility of continuous lighting. The deliciousness of the 85mm f/1.4 lens really brings her eyes to attention.

Keep It Relaxed

During part of the photo session in the studio, I decided to use continuous lighting. Lauraine is new to modeling for the camera and working in the studio, so the lack of flashes popping helped keep the atmosphere relaxed. The shorter telephoto length of an 85mm lens also meant I could work close and give instruction on posing. Slight adjustments to her hand or the tilt of her head could be more easily relayed at this distance.

The continuous light makes it so easy to adjust the lighting and the pose—I find it even easier than with the modeling lights of studio strobes, since what you see is truly what you get.

Background

The background was a four-panel room divider screen. Spilling a bit of light on it, and angling it properly, added a hint of color and texture in the background. This made the final setting for the portrait series a little more nuanced.

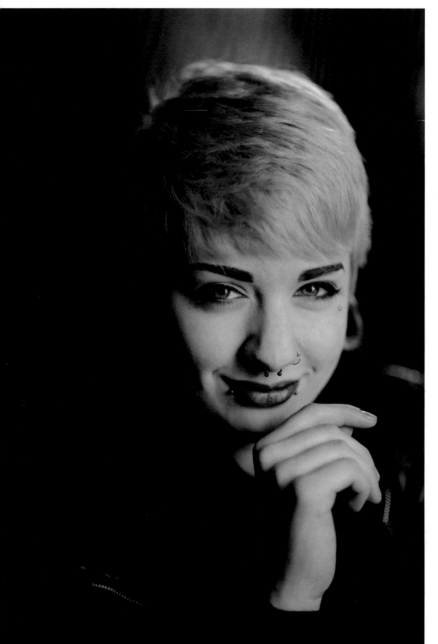

TECH SPECS:

1/500 second, f/1.4, 500 ISO
Nikon D4
Nikon 85mm f/1.4G AF-S
Westcott Spiderlites

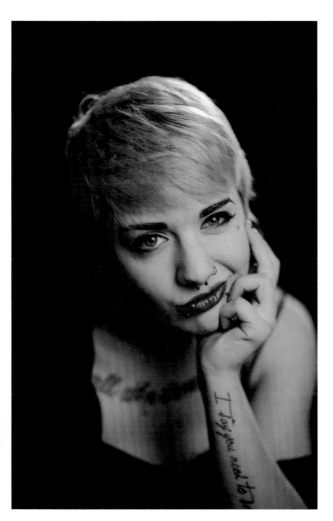

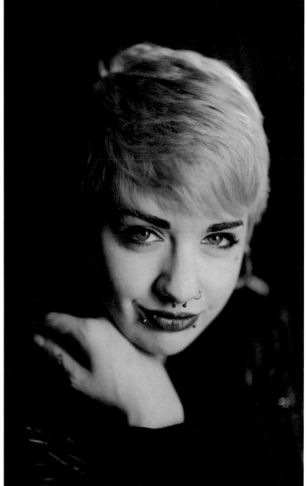

Lighting

For Lauraine's portraits, I used two Westcott Spiderlites: a TD6 with a 3x4-foot softbox and a TD5 with a 1x3-foot softbox. The larger softbox was the main light. The smaller softbox functioned as a hair light and spilled a little bit of light on the background. The pull-back shot (*right*) shows the placement of the lights.

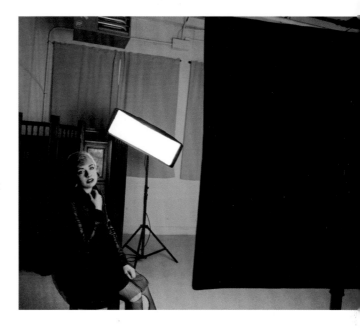

In the TD6 (main light), I used five bulbs that were daylight-balanced, plus one incandescent bulb so that the light went a little warmer. The TD5 (background light) only had daylight bulbs in it, so in the final editing, where the color balance of the image is adjusted, the hair light and background light went a touch colder.

41. DECONSTRUCTING A PORTRAIT

Subject and Concept

Chuck Arlund is an exceptional photographer whom I greatly admire—so when he and his son, Lachlann, visited New York, I wanted something a little out of the ordinary for my portrait of the two of them. The idea I had in mind was a wide shot, with a sweeping view of a street scene. I wanted to show movement all around them, while they remained still. In that sense, they would be isolated even among all the movement.

Times Square immediately came to mind as a place where there'd be a horde of people milling around—but also a wide enough place to shoot this. Still, the direction we could shoot in was

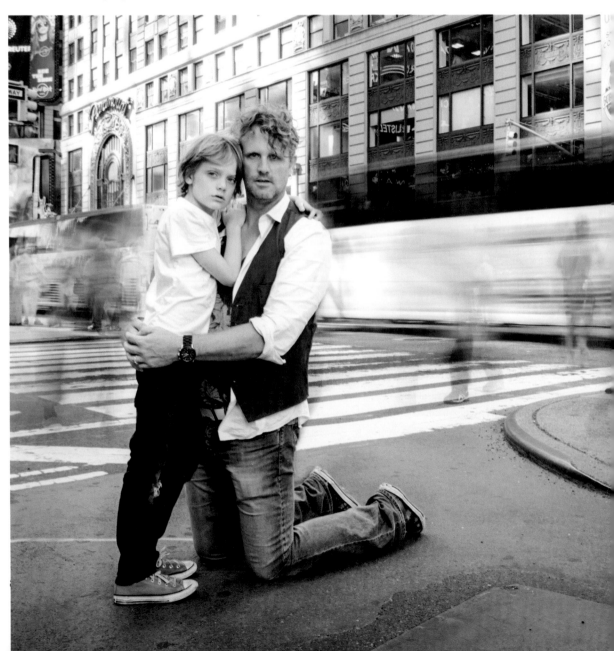

limited by the pedestrian flow, barriers, as well as a policeman who asked me to hurry up. So the pressure was on to make the idea work quickly.

Lighting and Shooting

To add enough light on them at f/22 (allowing for a 1 second shutter speed), I brought in a 600Ws Profoto Acute B2 power pack and a Profoto beauty dish. With this in place, it was just a matter of balancing the flash and the daylight (at a slow shutter speed).

I had to shoot at an angle here to get a clear view of the street without barricades in the way.

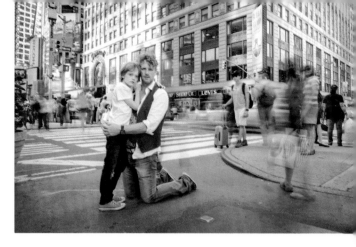

It was also a busy intersection, so people were more likely to be moving along. What happened though, was that people in the distance appeared sharper, because their movements were "smaller" from my camera's perspective.

A Composite Background to Simplify

Some people would linger and appear too sharp. As a result, the background in the original version (*above*) was too complex. To create the final image (*left*) I pulled five shots together to make the background more simple. This helped me keep the emphasis on the dad and his son.

In the end, I think the portrait is evocative and slightly mysterious, showing a tender, emotional bond that remains permanent amidst the craziness of the world. I hope it will draw the viewer in for a while, with this stillness juxtaposed against motion—although, in the breakdown of the behind-the-scenes decisions, some of the mystery is perhaps inevitably lost.

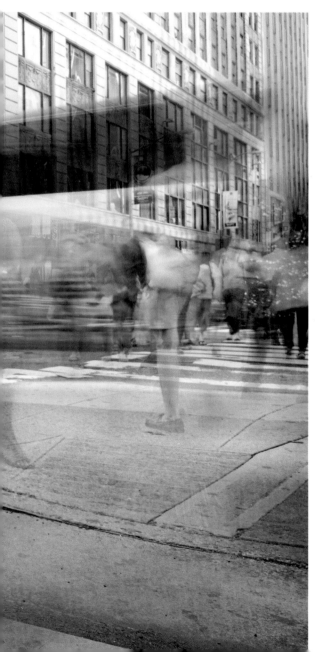

TECH SPECS:

1 second, f/22, 500 ISO*
Nikon D4
85mm f/1.4
Beauty dish, Profoto portable studio light
* *This translates to a more usual equivalent exposure of 1/125 second, f/2.8, 100 ISO.*

42. **URBAN BALLERINA**

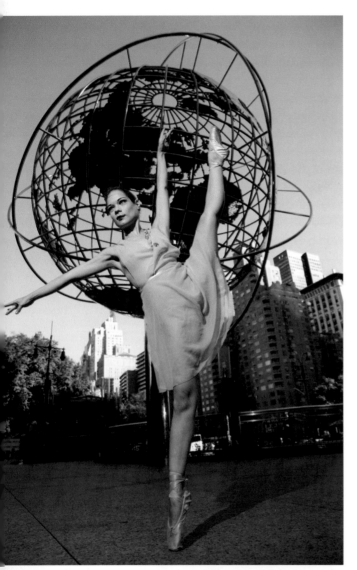

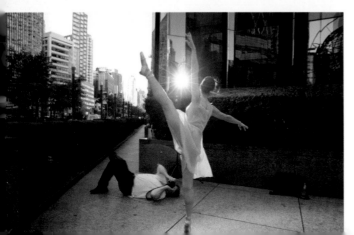

There is, of course, a certain incongruity in posing a ballerina against a cityscape. Yet, there is a beauty in the momentary stillness in Viktoria's peak movement, versus the bustling street down below. Her elegant movement somehow just looks really great against the backdrop of Manhattan's skyscrapers.

Traveling Light

For the lighting in this photo session, I decided to travel light. The Canon 600EX-RT, with its built-in wireless control, offers the sweetest intersection of power, versatility, and control. The flash's output (and mode) are easily controlled from the camera's position.

The First Look

The image and pull-back shot to the left show one way I positioned my speedlight relative to the scene and subject. You can also see my own position, low down on the ground, to get the desired perspective.

The Second Look

We were working in the late afternoon in New York, with the sunlight glinting off the glass buildings. This looked dramatic, but the sunlight that was reflecting off the buildings wasn't

TECH SPECS:

1/250 second, f/4.0, 100 ISO
Canon 6D
24–70mm f/2.8L II at 24mm
Canon 600EX-RT Speedlite, manual

TECH SPECS:

1/250 second, f/5.6, 400 ISO
Canon 6D
24–70mm f/2.8L II at 24mm
Canon 600EX-RT Speedlite, manual

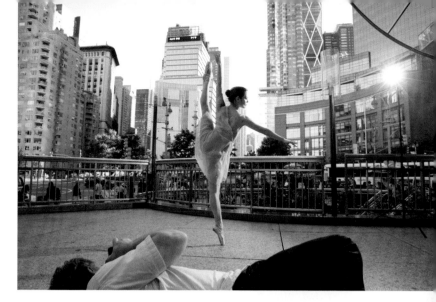

consistent and didn't necessarily fall in a place where we could use it. For the image to the right, I created my own light with an off-camera speedlight. This was placed just out of the frame so that it intentionally flared but also gave beautiful rim light on Viktoria.

Camera Settings

The exact point where Viktoria stepped would change ever so slightly between shots and her movements were quick, so I had to pre-focus. Given the slight changes in her position, a super-wide aperture would just have meant more missed shots. So I settled on an aperture of f/5.6 for the image to the right.

At her peak movement, she was quite still for half a second, so I didn't need action-stopping shutter speeds. Setting my camera at $^1/_{250}$ second worked fine. Even though this is higher than the maximum flash sync of the Canon 6D, and there was some loss of flash power, there was enough headroom because we were working at fairly close distances with bare flash.

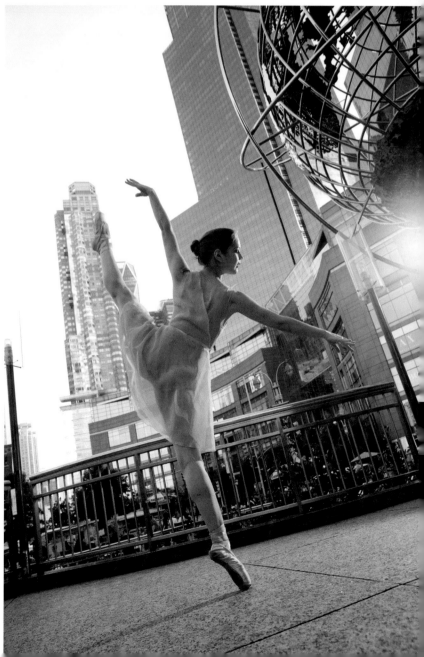

43. REGAL PORTRAIT WITH A FERRET

*L*ynn Clark is an accomplished boudoir photographer—but I didn't want to go with the obvious idea of doing a boudoir photo session with her.

Location Selection

Lynn's boudoir studio is home-based, and I spent some time looking around figuring out angles and lighting and backgrounds. I figured out where we could shoot a few basic portraits around her studio. They would be good portraits, but nothing extremely engaging—yet.

Inspiration Strikes

Lynn and her family keep six ferrets as pets. They also run a ferret bed-and-breakfast in Denver, where they take care of ferrets whose owners are on vacation. So there are ferrets around—and they are adorable. In chatting with Lynn, she mentioned Leonardo Da Vinci's portrait of a woman with an ermine—as well as a portrait of Queen Elizabeth with a ferret. (Google to see these masterworks for yourself.) That's the moment when the idea clicked!

Executing the Concept

Throwing the chandelier in her studio out of focus and keeping it in frame, we'd have a glowing halo of light above Lynn. The regal red drapes worked, too. To finish the look, we needed a costume. We didn't have anything nearly as ostentatious as a crown, so we went for a tiara and some "bling" jewelry. A red dress stood in for a red cloak. Finally, we added Elliott, the energetically curious ferret you see in the photo.

TECH SPECS:

1/200 second, f/4.0, 1600 ISO
Nikon D4
Nikon 70–200mm f/2.8 VR II
Litepanels Chroma video light

The final portrait of Lynn is a whimsical homage to the portrait of royalty with a pet ferret. There's an absurdity about it. Hopefully, the portrait is also quite cute and amusing. I do think it shows that playful aspect of Lynn—even though she insists she's actually a serious person.

Lighting

I lit this portrait with the Litepanels Croma LED video light, which is handy in that you can continuously change the color temperature to match that of the available light. I wanted a bit of a spotlight on Lynn, but with the light feathered up to highlight her face and the ferret. The pull-back shot below shows the setup.

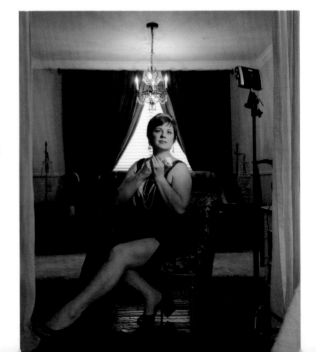

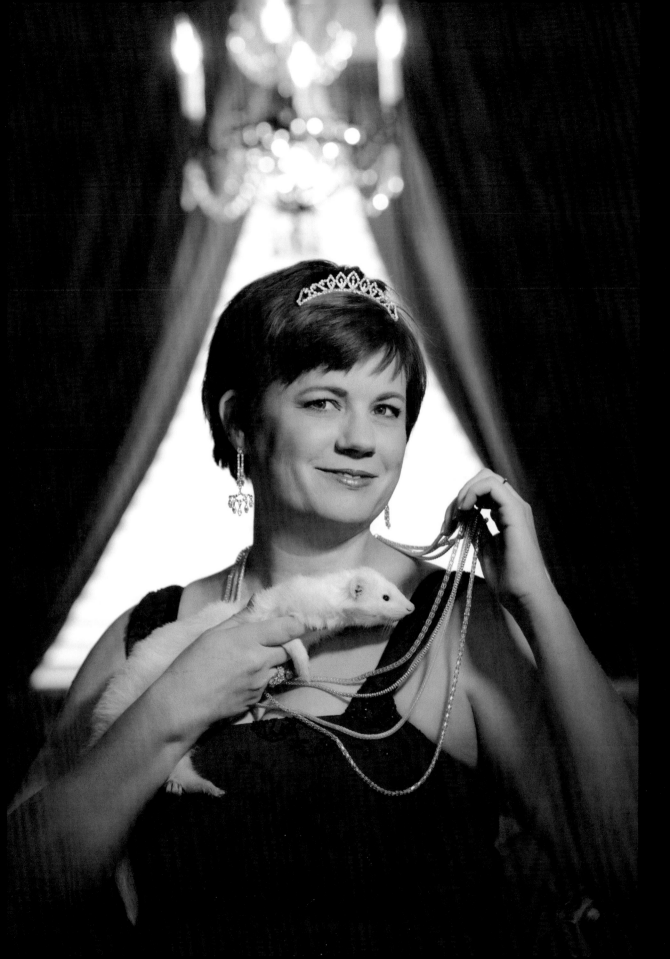

44. WORKING TOWARD THE FINAL IMAGE

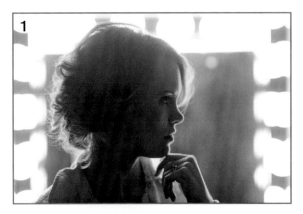

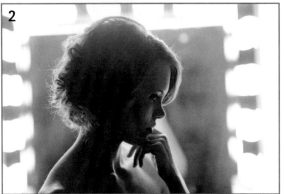

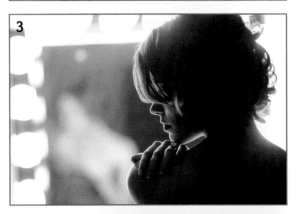

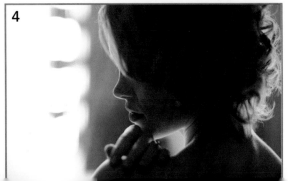

*T*hese photographs of Jessica were taken just before a photo shoot. We created a series of images as we worked toward a few portraits that would work, improving on each composition and pose, step by step.

Evolution

This process of refining each aspect of the shot relates directly to an idea presented in the foreword to this book—that the *final* image we are presented with is usually not fully formed as a *first* image. It is, almost invariably, the last step in a progression that worked toward it.

The final result shown here (*facing page*) is a little bit of everything—a wonderful subject, an opportunity, and then (over the course of several photographs) finessing the image.

We can easily finesse an image just like this until we have something that *really* works. Just don't give up too early.

Step by Step

The first image (*1*) shows where we started. In the dressing area of the studio, there was a mirror with light bulbs around it. I asked Jessica to turn to her side so I could see her profile.

It was a start, but the jacket was too bulky and too noticeable. I wanted the portrait to be about her, so I asked her to remove it—which gave us our second image (*2*). I like the result, but I can see her brightly lit arm (and myself) reflected in the mirror.

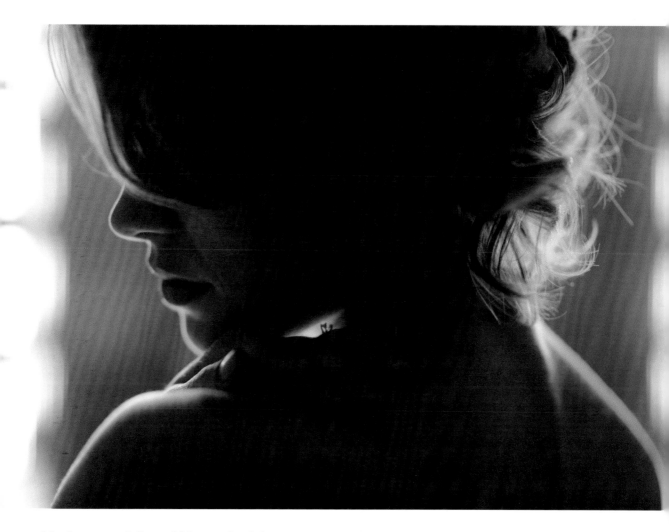

Moving to my left would have solved the reflection issue—but there was something else missing. The photo lacked a sense of mystery. For the third image (*3*), I asked Jessica to turn around and look to her left. I had her bring her hand into the frame, to add more of that sensuality to the image. However, her reflection in the mirror was too distracting.

Through a series of images, I tried to hide her reflection, which created distracting hot-spots in the mirror. I needed to move subtly to the side and have Jessica rotate ever so slightly toward the camera—we're nearly there (*4*)!

The photo still had that slightly distracting reflection of her hand in the mirror. However, a

TECH SPECS:

1/200 second, f/1.8, 1600 ISO
Nikon D4
85mm f/1.4G AF-S
Available light (light bulbs around mirror)

slight change in her pose hid that and got us to the final image, shown above.

Often enough, we can easily finesse an image just like this until we have something that *really* works. Just don't give up too early.

45. **WORK THE SCENE**

*A*s part of my destination wedding photography coverage, I offer an extended photo session around the exotic locale after (or before) the wedding date. While we're there, we may as well make the most of the opportunity.

The day after Desha and Kyle's wedding in Aruba, we drove around the arid areas of the island—away from the touristy parts. There was a short rainstorm while we were driving, and the landscape looked really crisp. Offsetting the couple against this stark landscape just seemed like a great idea.

Desert Scene

For our first look (*below*), I posed the couple into the light. Working with a wide-angle lens to give me a sweeping view, I experimented with various compositions of this scene, but liked the off-center version the most.

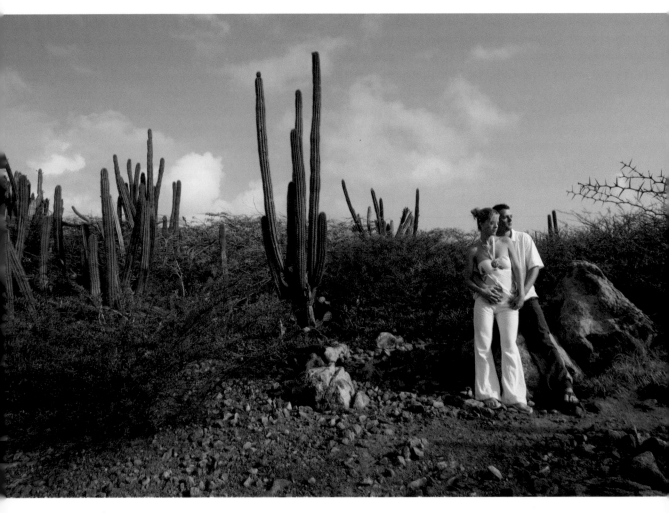

TECH SPECS (FACING PAGE):

1/250 second, f/9.0, 100 ISO
Canon 1D Mark IIn
Canon 16–35mm f/2.8L
Available light

TECH SPECS (RIGHT):

1/1000 second, f/5.6, 100 ISO
Canon 1D Mark IIn
Canon 70–200mm f/2.8L IS
Available light

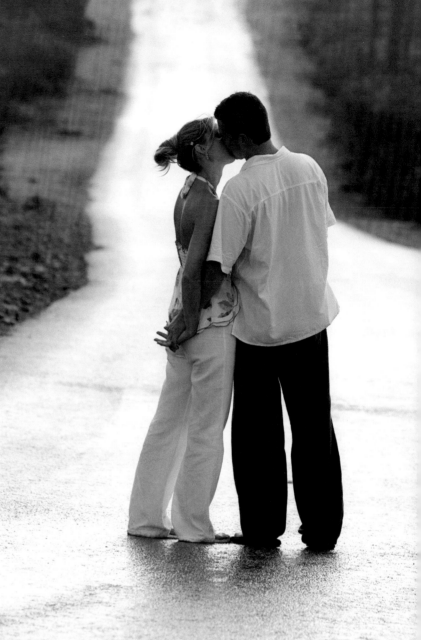

For any given portrait setup, I always shoot wide and tight, vertical and horizontal, and high and low viewpoints. This way I get a variety of images. In the culling process later on, I can then pick the ones that work best for me and for my clients.

Of course, there's usually more than just one photograph . . .

In the Road

I was inspired to create a second look for Desha and Kyle when I saw the road surface glistening with the rain (*right*). I stood in the road and asked the couple to slowly meander down the street. It was perfect. I instantly liked what I saw in my viewfinder. A vertical composition like this just made the most sense for the scene. I shot it with the 70–200mm lens at 175mm for a compressed perspective.

Small Changes, Big Difference

Just a minute and a half passed between these two images—and the clouds came over, softening the light a bit. That didn't really matter, though; the second image would have worked with sunlight as well.

The key idea here is that changing your position and moving around can often produce images that look hugely different, because:

1. You're changing your background, and
2. You're changing your position in relation to the light.

46. FIND THE *OTHER* ANGLES

*W*orking with a film noir theme, a group of photographers in my area arranged a shoot-out. These are two of my images from that session.

Lighting and Posing

Jill Susie, one of the models at the shoot-out, had a hairstyle and dress that were strongly reminiscent of the flapper era. This really suited a sexy pose and styling.

Keeping with the theme, the lighting in the photos needed to be subdued and mysterious. With that, I didn't use flash at all but decided to use only a video light. Since I knew I might want something stronger than my usual LED video light, I decided on the more flexible and powerful Lowel ID-Light.

For both images here, the Lowel ID-Light was held aloft by someone else. The position of the light should be discernible by how the light falls on her and how the shadow pattern appears under her nose.

TECH SPECS:

1/500 second, f/1.4, 1600 ISO
Nikon D3S
Nikon 85mm f/1.4G AF-S
Lowell ID-Light

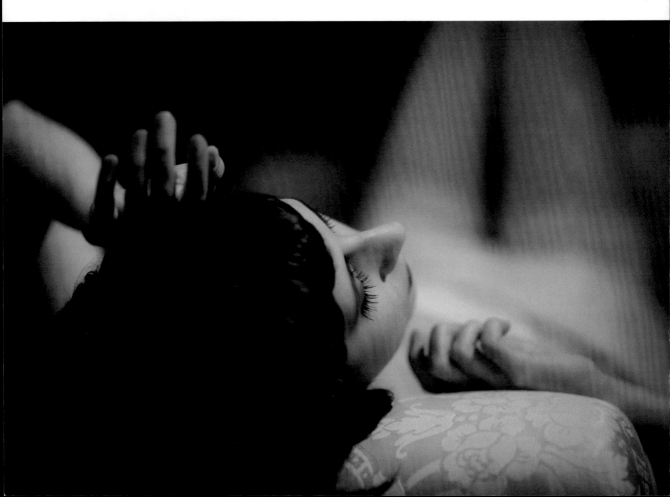

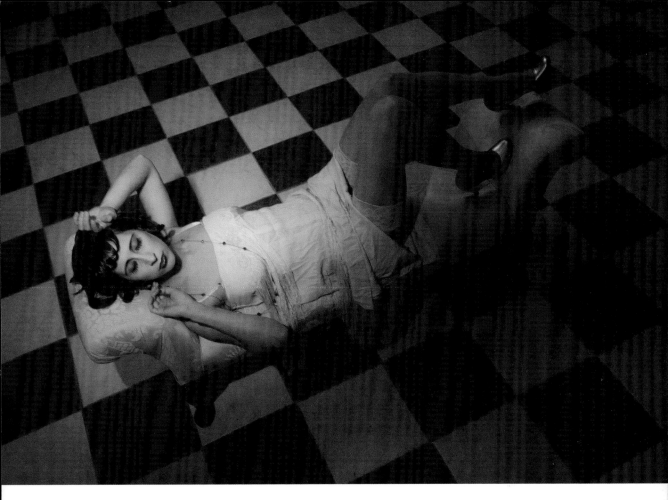

Working the Angles

The image above is the photograph that was easier to envision. The pattern of the tiles in the lobby immediately drew my attention as a possible idea. The way the tile pattern recedes helps draw your eye to our model, as does the spotlight effect of the video light. I stood on a short ledge and shot down to create this image.

The image on the facing page shows a different angle that my friend Peter Salo found. The irony here is that the first time Peter and I met was at another photo shoot-out—and I was insistent he find a different angle, rather than just shooting from eye-height. I even pushed him down on the ground to convince him. And here we are, a few years later, with him finding the alternate angle that I didn't immediately see. Using the 85mm f/1.4 lens wide open gave that shallow depth of field.

TECH SPECS:

1/80 second, f/5, 1600 ISO
Nikon D3S
Nikon 24–70mm f/2.8 AF-S
Lowell ID-Light

The position of the light should be discernible by how the light falls on her and how the shadow pattern appears under her nose.

47. **PLAYFUL PORTRAITS**, PART 1

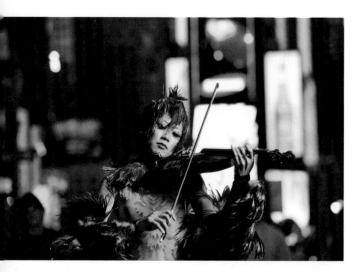

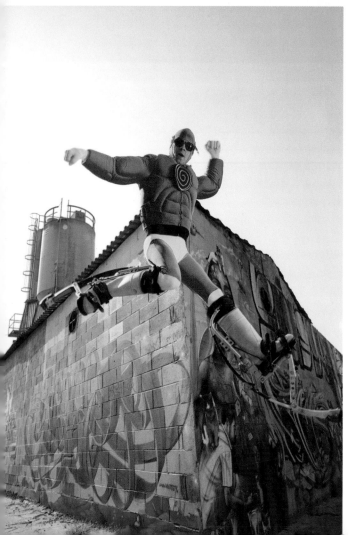

*I*rene Fong and Michael Saab are at the core of the Brooklyn-based performance group called the Modern Gypsies. Over the past few years, I have photographed the Modern Gypsies several times for their own promotion.

Concept

Since they are always in outlandish costumes, I also wanted to photograph them as themselves—sans costumes and stage makeup. However, totally straight-forward portraits wouldn't have been true to who they are. I still wanted to give the portraits some of their crazy inventiveness.

The idea I came up with was to have Irene's portrait be slightly surreal. Along with her trademark see-through violin, I wanted to include Michael, but as a secondary subject. Some of his acts have him bouncing around on stilts while in costume, so that's how I decided to show him in the background. By using a wide aperture (f/2), I was able to throw him out of focus and keep this portrait about Irene.

High-Speed Flash Sync

I used two lights here—a speedlight in a softbox on Irene and a direct, unmodified speedlight on Michael. Shooting outdoors, the f/2 aperture implied a fast shutter speed, putting me in high-speed flash sync territory. With the available light as the dominant light source, the flash wouldn't be able to freeze the action on its own, so I needed a $^1/_{1000}$ second shutter speed.

◀ Images from previous sessions with the Modern Gypsies—in full costumes and makeup.

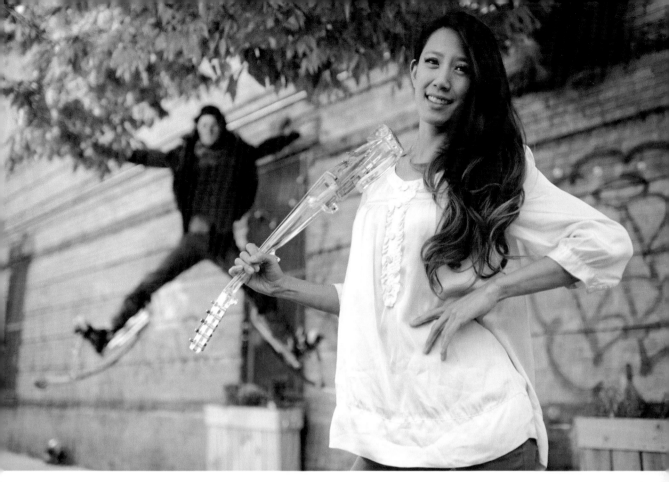

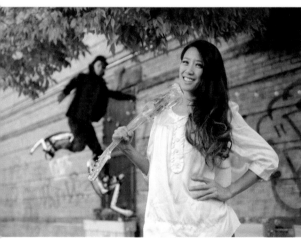

▲ Two final looks from the session.

▶ The positioning of the two lights, with Michael shown standing where Irene would be in the final sequence of images.

48. **PLAYFUL PORTRAITS**, PART 2

▲ Shooting natural-light portraits of Michael against a graffiti-covered wall.

*F*or my portrait of Michael (of the Modern Gypsies), I wanted something that showed some of his free spirit and creativity. Shooting in Brooklyn, we stopped at one of the numerous graffiti murals that speckle the urban landscape of this borough of New York City.

A Preliminary Look

We started off with a basic portrait with him against the colorful graffiti (*below*)—but I wanted more than just someone posing in front of a mural. I wanted to show more of his energy and playfulness.

A More Energetic Look

A wonderful thing about photographing creative people and entertainers is that the best of them can just turn it on pretty much any time. So

Michael easily started to goof around with his bowler hat, whirling it around.

I shot a long sequence of images, but the one I liked the most was when he attempted to

▼ This simple portrait of Michael against a colorful background was nice—but it didn't quite capture the creativity and energy I wanted to show.

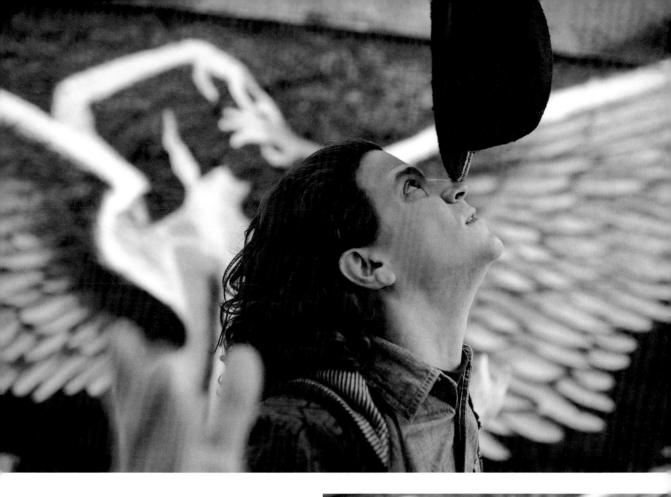

balance the hat on the edge of his nose (*above*). Without mirroring the graffiti mural in pose, there is still a kind of symmetry in terms of the gesture; the wings spread and Michael's hands extend out as he balances the hat.

It's an incongruous image perhaps, someone randomly balancing his hat on his nose. But, for me, it captures part of the essence of someone who is constantly inventive and playful.

Lighting

The technical details are simplicity itself. The lighting was all natural; the overcast weather made for soft light. I also used a wide aperture to create separation between my subject and the background.

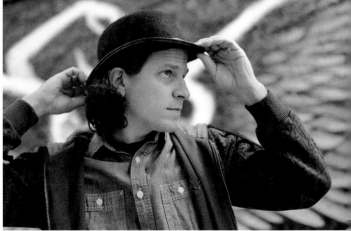

TECH SPECS:

1/500 second, f/2, 200 ISO
Nikon D4
35mm f/1.4
Available light

49. **FILM NOIR**

*W*orking on images for character actor Mike Larose's portfolio, we decided on a film noir theme that would depict him as a character from a Hitchcock movie, but in color. He dressed the part. Shooting around New York's City Hall, the imposing architecture suited this theme well.

Camera and Composition

I traveled light on this day, using the Fuji X100s camera, which is smaller than my usual DSLRs. The Fuji X100s has a fixed 35mm-equivalent lens, so there is a specific field of view that you have to work with. Any compositions have to work with this lens—or else you have to crop

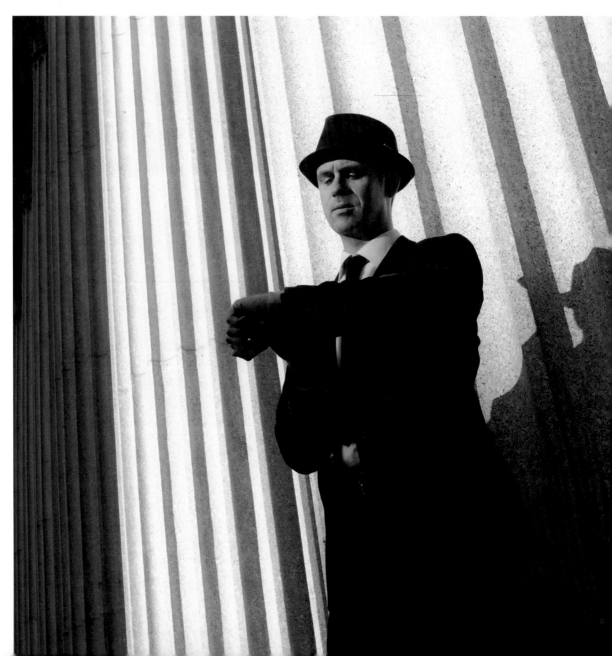

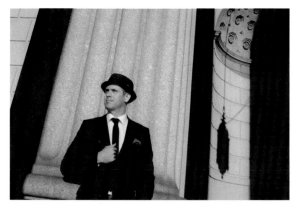

▲ One of my initial test shots. I liked the pendulous shadow of one of the lights there.

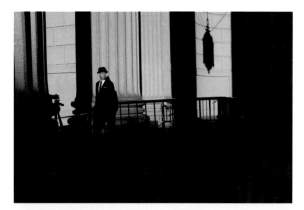

Scene-Setters

Taking a scene-setter image like this gives me a better sense of whether there is something to work with in a location. Very often, even though we can visualize what we want in an image, it somehow comes together better when we see it in the confines of the frame—even if just on the back of the camera.

in postproduction. I don't like heavy cropping because you lose real estate; the more you crop, the more resolution and detail you lose.

So I really prefer working within the confines of the specific lens to find the composition that works well. In this case, however, looking at the original out-of-camera image (*below*), the blue sky on the left-hand side seemed superfluous. So I cropped it to this final image (*left*) for simplicity. This left us with only the character, the lines of the pillar, and his shadow.

The mood is now more ominous perhaps. With him looking at his watch, there's also a sense of urgency. That simple gesture added a touch of extra drama to the image.

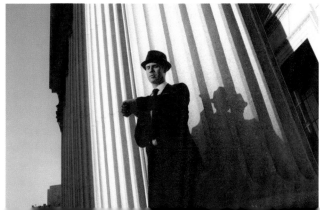

50. PUNCHING UP PLAIN WHITE WALLS

*W*hile photographers like Irving Penn have made beautiful use of plain white walls as portrait backgrounds, sometimes we need something more to tell our subject's story. That was my challenge for this portrait session.

Subject and Concept

Michael Downey, a New Jersey photographer, should be well known to visitors at Unique Photo. He's a super nice guy, but I didn't think wild and crazy posing would suit him. Instead, this fairly simple lighting setup let me add some flavor to the portrait. With this technique, a straightforward portrait against a white wall became a kaleidoscopic adventure in color.

More Than a Shadow

One of the common approaches to punching up plain white walls is to use the person's shadow

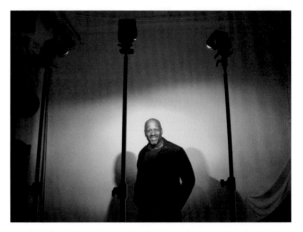

▲ The three bare speedlights, each with a gel over the flash.

against the wall as part of the overall design of the image. Here, I took it a step farther by adding three gelled flashes (red, green, and blue) to cause three shadows in different colors.

Note that those three colors are the primary additive colors, so where all three lights overlapped there was white light—giving me natural skin tones. (Shooting in RAW helps with correcting any shift in color if the gels are of unequal strength.) Where only two lights overlapped, you'll see the shadow shifted in color accordingly. For example, where the red and blue overlap but green is blocked, you get a magenta color.

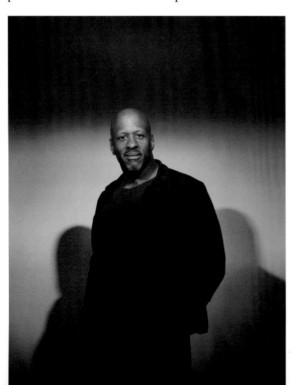

TECH SPECS:

1/160 second, f/8, 200 ISO
Nikon D4
Nikon 70–200mm f/2.8 VR II
three bare speedlights with gels

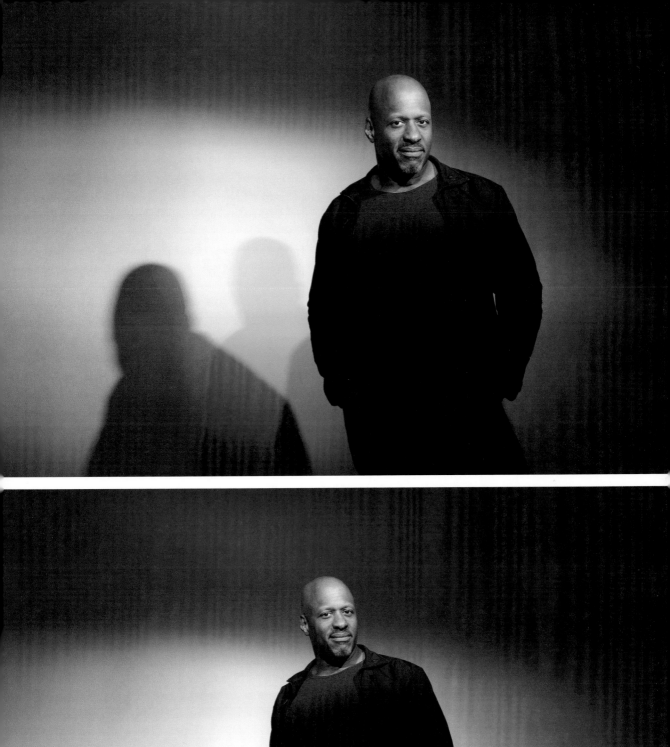

51. CLASSIC STYLING

*H*aving some kind of idea what you want to do at the start of a photo session is always helpful, but the ultimate success of any photograph is most often the result of a variety of choices all coming together—posing, composition, lighting, and more.

Setting and Clothing

The imposing pillars and leading lines of the court house in Denver, Colorado, made for a strong, uncluttered background. The model, Elizabeth Haynes, had this simple but elegant black dress as part of her wardrobe; it was a perfect complement to the setting.

Lighting

In the image on the facing page, her shadow helped pull the shot together. It looks like there was a bit of sunshine sneaking through a thin layer of clouds—and the image pops!

To get that dramatic light on her, I used undiffused off-camera flash. Since this is a small source, you have to be very specific in posing your subject to ensure the lighting remains flattering. Posing "into the light" usually works best. The way the shadow fell behind her was an accidental little bonus. I'll take it when it comes.

TECH SPECS:

1/250 second, f/5.6, 100 ISO
Nikon D4
Nikon 24–70mm f/2.8
Undiffused off-camera flash in TTL mode

An Aperture Change

While shooting, I decided to change from f/4 (*below right*) to f/5.6 (*facing page*) to pull the ambient light lower and make the light from the off-camera flash more dramatic. This decision hinged on how dark I wanted the ambient light to appear. This was an artistic decision. I had other good choices, but I find the more dramatic effect is usually the more interesting one.

Camera Height

I shot slightly upward to accentuate her legs. Shooting down would have created a strange foreshortening effect. When photographing people with a wide lens (here, about 38mm), it is best to shoot from belly-button height—exactly where an old twin-lens reflex camera would have been held. This way you're not shooting down or up, so any spatial distortion is minimized.

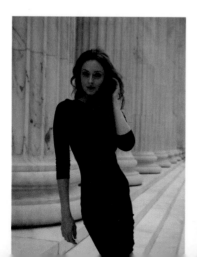
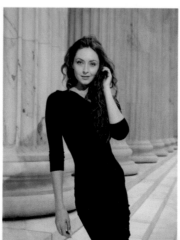

◄ *(left)* The image photographed with available light only. (1/250 second, f/4, 100 ISO)

◄ *(right)* The image with the addition of off-camera TTL flash. (1/250 second, f/4, 100 ISO)

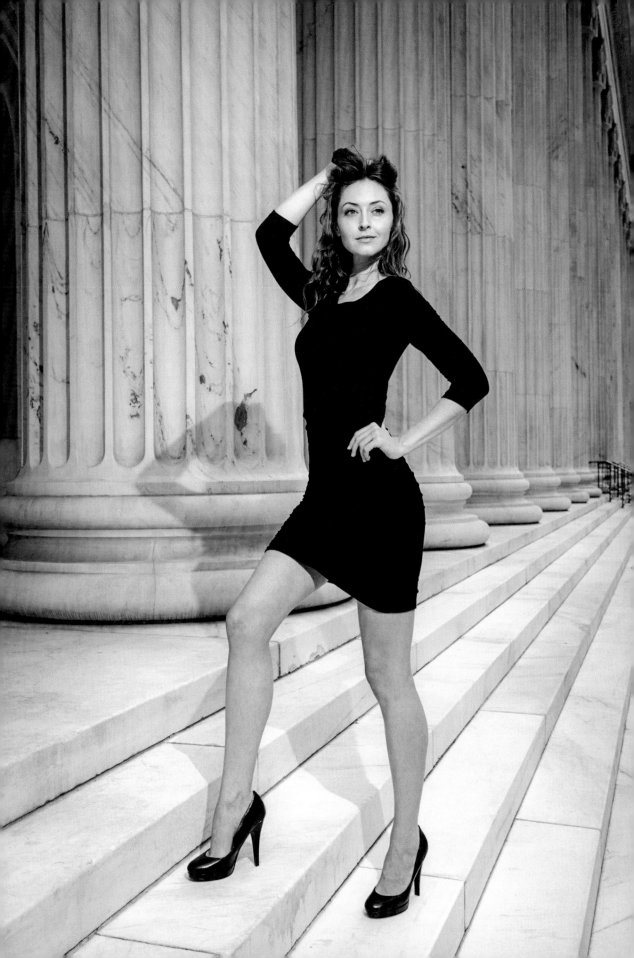

52. PROMOTIONAL PORTRAITS

My friend Mike Larose is a New York actor and musician. You might remember seeing him elsewhere in this book in completely different guises (sections 38 and 49).

A Solid Start

For these portraits, we worked outside along a pathway in a wooded area. I knew I wanted to shoot tight with a 70–200mm lens at the longer end of the zoom. This would compress the perspective and isolate exactly what I wanted as a background. This choice goes hand-in-hand with carefully positioning myself and my subject in relation to the background. It's not accidental.

I framed Mike against the highlights in the background to create a natural vignette. This is commonly how I work when doing portraits on location (see section 2 for another example). It's a specific way of shooting that gives consistent results as a baseline—in other words, the minimum here already looks very good.

TECH SPECS:

1/200 second, f/4, 400 ISO
Nikon D4
Nikon 70–200mm f/2.8 VR II
Two off-camera flashes; main light in gridded strip box, rim light in reflector with 10 degree grid

Making It Better

To control the light, I added studio lighting with the Profoto B1, a battery-powered flash unit that delivers 500Ws. (Of course, this could also have been shot with speedlights and similar light modifiers.) A gridded strip box on Mike lit him selectively, while a 10 degree grid on a reflector from behind gave the rim light.

Two Compositions

The vertical version was shot at 200mm, while the tighter horizontal portrait was shot at 190mm—there was no big change in the focal length. I kept my zoom racked to the max (or close) and then moved around to keep that compression.

As noted in section 29, I resisted the temptation to just zoom wider. Using a consistent approach like this helps guarantee

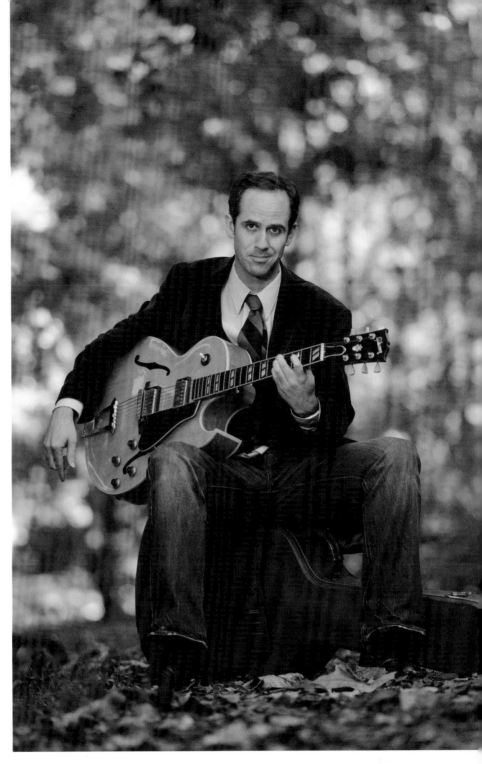

really good photographs. It provides a solid foundation. From there, we can improvise, looking for ways to refine the approach and create images that truly stand out.

53. A VINTAGE MOTORBIKE

Back in section 25, we saw John in his workshop. John also has two vintage motorbikes; one is from the WWI era and the other is this 1928 German-built Triumph. The sidecar was made by Hindenburg Metalworks—yup, the zeppelin guys. John's friend, Barbara, frequently accompanies him to shows and rallies, so she also came along for this photo shoot. After all, there *is* a sidecar!

Image Concepts

Using different setups, I photographed a few sequences of John and Barbara with the motorbike on location. I liked this dramatic series the most, with the light from behind casting a shadow in front of them. I wanted the light to etch the frame of the motorbike and sidecar, without revealing too much detail—after all, this was to be a portrait of John and Barbara. However, I also took a number of other images where the motorbike was better lit, just to have the variety.

Lighting

I worked with two Profoto monolights. The light from behind was from a Profoto 50 degree Magnum Reflector, because I needed a big light behind them.

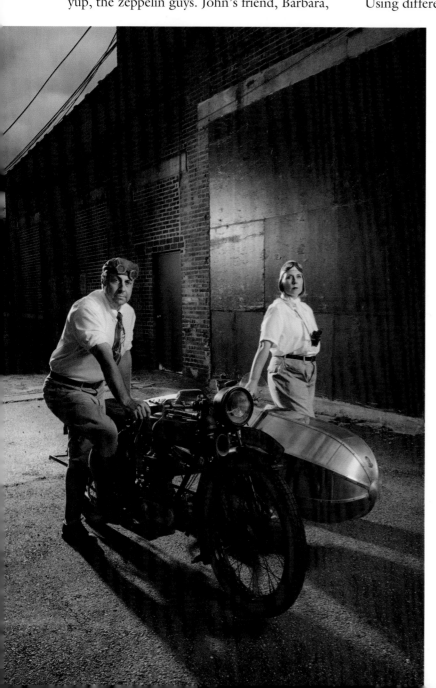

TECH SPECS:

1/250 second, f/14, 200 ISO
Nikon D4
Nikon 24–70mm f/2.8
Two off-camera flashes; main light in softbox, backlight in Profoto Magnum Reflector

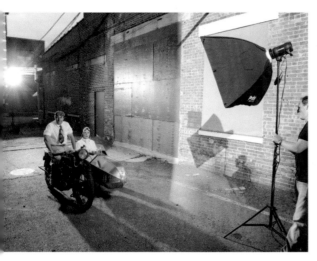

▲ A pull-back shot showing the lighting setup.

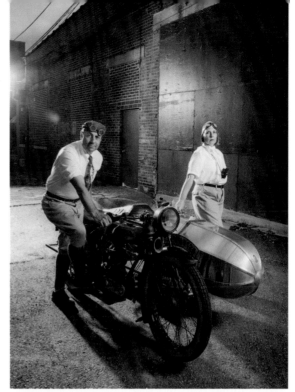

The light stand needed to be outside the frame but still cast enough light on them to create that shadow in the front. The Profoto Magnum Reflector concentrated the beam.

The light in the front of them was a Profoto D1 Air 500Ws monolight, used with a Profoto 3x4-foot softbox. This created large, soft lighting on John and Barbara. The main light was placed to camera right—not on-axis with the camera. This helped maintain the dramatic quality of the light, so it didn't flatten out the subjects.

A Little Flare

For a few images, I allowed the lens to flare. Because the light in the background was so strong, I had to use my hand on the edge of the lens to control the amount of flare. I shot and checked a number of times, until I had a few images where the flare wasn't too overpowering.

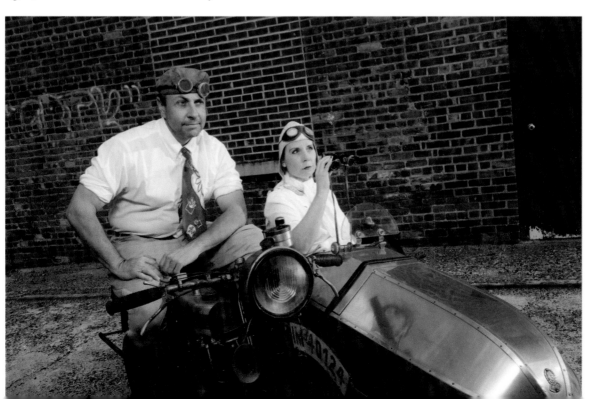

54. **SPEEDWAY RACER**

Photographing speedway racer, Courtney Lefcourt at the Bethel Motor Speedway was a two-part technical challenge.

Challenges

While Courtney is undoubtedly photogenic—and speedway racing is exciting to watch—the racetrack itself wasn't exactly a visual feast. It was a barren oval strip of tarmac at an angle. That was the first challenge. To make the scene work as a background, I had to accentuate Courtney more and the racetrack less—while still keeping it relevant as an environmental portrait. The second part of the challenge was that the overhead sun was very bright.

Solutions

For the tighter portraits, I could eliminate the distracting background—the crash barrier and trees—by shooting from an elevated viewpoint (*below, facing page top*). Standing on a small stepladder, I could exclude any of the edges of the racetrack. That way, I achieved visual simplicity by eliminating clutter.

While a higher viewpoint helped accentuate her, working under the bright sun meant

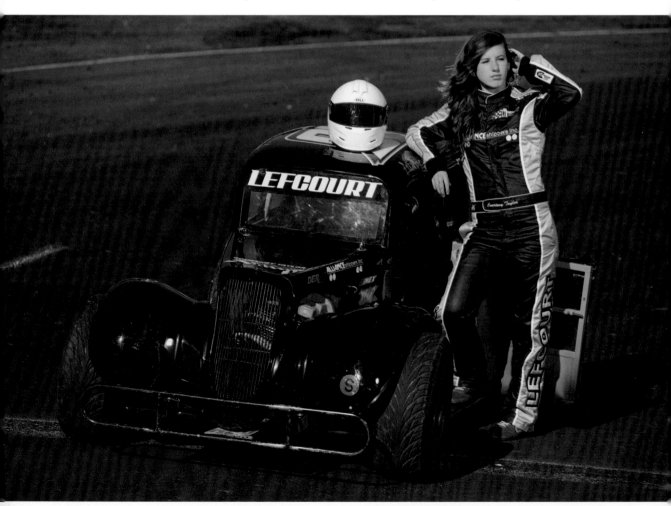

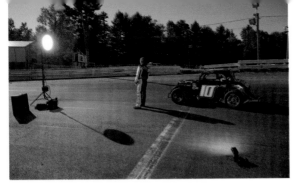

▲ The lighting setup, with a Profoto Acute B2 600Ws power pack and a Profoto beauty dish with a sock.

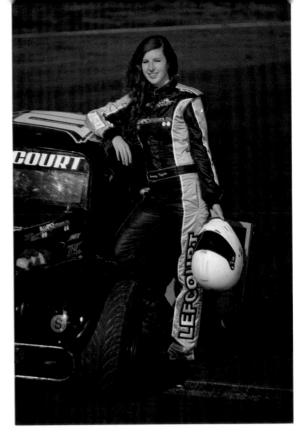

TECH SPECS:

1/250 second, f/5.6, 100 ISO
Nikon D4
Nikon 70–200mm f/2.8
Undiffused off-camera flash in TTL mode
B+W 77mm 0.9 (3 stop) ND filter

shooting at small apertures when I would have preferred a wider setting. Adding a 3-stop neutral density filter brought my aperture to f/4.5, giving me just enough depth of field.

To create even more separation, I set up a speedlight behind her at full manual output. It gave that bit of rim light that makes Courtney really pop out from that neutral, out-of-focus background.

The last piece of the puzzle was the addition of a Profoto light with a beautify dish; like the speedlight behind her, this was set at full power.

The speedlight just had to add that bit of rim light from behind. The Profoto had to do the heavy lifting by more than just matching the bright sunlight, thereby opening up the shadows and giving flattering light on Courtney.

By keeping to a specific thought process in adding off-camera light to strong sunlight, the photo session was made easier—and the chances for success were significantly better.

▶ The wider shots were done without a neutral density filter, since I didn't so specifically need a shallower depth of field.

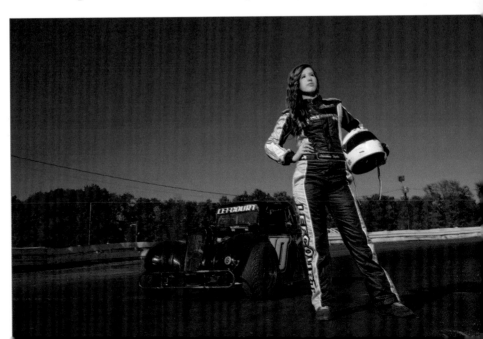

55. BEST ON-LOCATION LIGHT MODIFIER

For this session, I met up with my friend Mike Allebach, a wedding photographer based in Philadelphia (www.mike allebach.com). We selected an intriguing venue, Tattooed Mom's, which was ideal for portraits with a more gritty look.

Scene and Composition
Of the various setups we shot, I most liked the one above. The semicircular pattern to the graffiti artwork and the symmetry of the furniture drove me toward keeping this a very central composition. Everything in the frame pulls you in toward Mike's intense expression.

Controlled Falloff
The light levels inside were low and I wanted to retain the atmosphere of the place. I couldn't use an umbrella, since that would just blast light all around. Instead, I opted for a 1x3-foot gridded

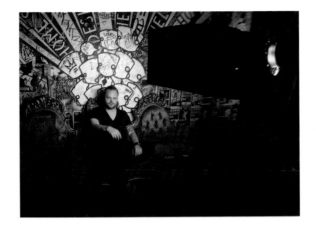

TECH SPECS:
1/50 second, f/4, 400 ISO
Canon EOS 5D Mark III
24–70mm f/2.8 II USM
Profoto flash with 1x3-foot gridded softbox

softbox—my favorite light modifier for location shoots like this one. Shooting at $^1/_{50}$ second and f/4 at 400 ISO retained enough of the ambiance of the place, but it also allowed me to spotlight Mike. The pull-back (*above*) shows how well the gridded narrow softbox contained the light. The controlled falloff from this light was instrumental in these portraits.

The compact Profoto RFi 1x3-foot softbox (along with the 50 degree 1x3-foot softgrid) is easy to carry around, so I keep it permanently set up as a portable light modifier when working with the studio-type Profoto lights.

TTL Exposure

Shooting inside, I didn't need full-blast, matching-the-sun kind of power but a more delicate touch of light. I started off shooting in TTL mode on the Profoto B1 portable studio flash. The TTL mode of these units is surprisingly accurate for such powerful lights.

However, with ever-changing compositions, shooting wide and tight, the TTL exposure did vary. To ensure consistent results, I picked one of the exposures that looked correct on the back of my camera, then simply set the Air Remote TTL controller to manual mode. That locked the desired exposure.

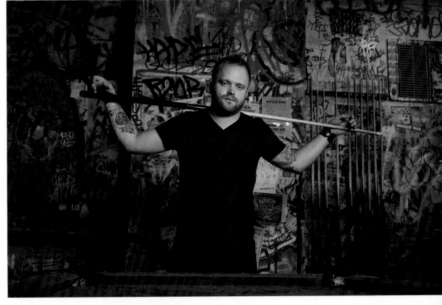

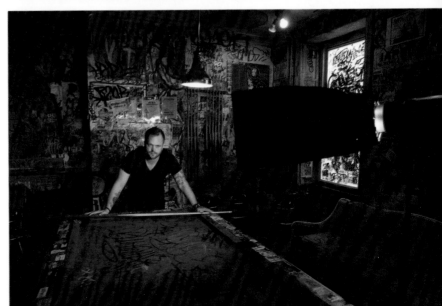

56. NEW YORK CITY ROOFTOP

For this photo session with Heather (www.heatherberman.com), a New York actor and dancer—and former Rockette—we had access to the rooftop of her New York City apartment.

Concept

I wanted to use the dramatic sun and sky to showcase Heather's vivid dress and elegant

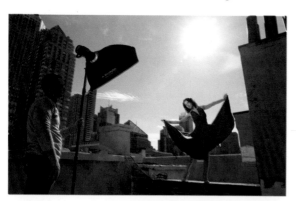

moves. There was no need to pose someone who works as a professional dancer. She had it! So it was just up to me to figure out where exactly I wanted to pose her and how to light her.

Lighting and Exposure

To create these images, I shot in manual mode, at full power. The light on Heather was softened (and controlled) with a gridded Profoto 1x3-foot softbox. In this case, the use of the gridded softbox was less based on the need to control the spill of light (as in section 55). Instead, the appeal was that it's a fairly compact softbox that is easy to carry around in New York—and easy to maneuver through windows, onto fire escapes, and up to the rooftop. Oftentimes, the choice of equipment is less exactly based on what is ideal in terms of lighting, but rather on what is physically practical and on hand.

TECH SPECS:

1/160 second, f/14, 100 ISO
Canon 6D
Canon 24–70mm f/2.8 II
Profoto flash with 1x3-foot gridded softbox

Depth of Field

I needed to match the exposure for the bright sky. Unfortunately, I had forgotten my neutral density filter, so I had to shoot at f/14—but the lack of control over the depth of field doesn't bother me here, since it really is about Heather, her dress and the blue sky. The neutral density filter would have brought the exposure down by 3 stops, turning the f/14 into an f/5 for the same ambient and flash exposure. (Check sections 54 and 36 for other examples of the use of a neutral density filter.)

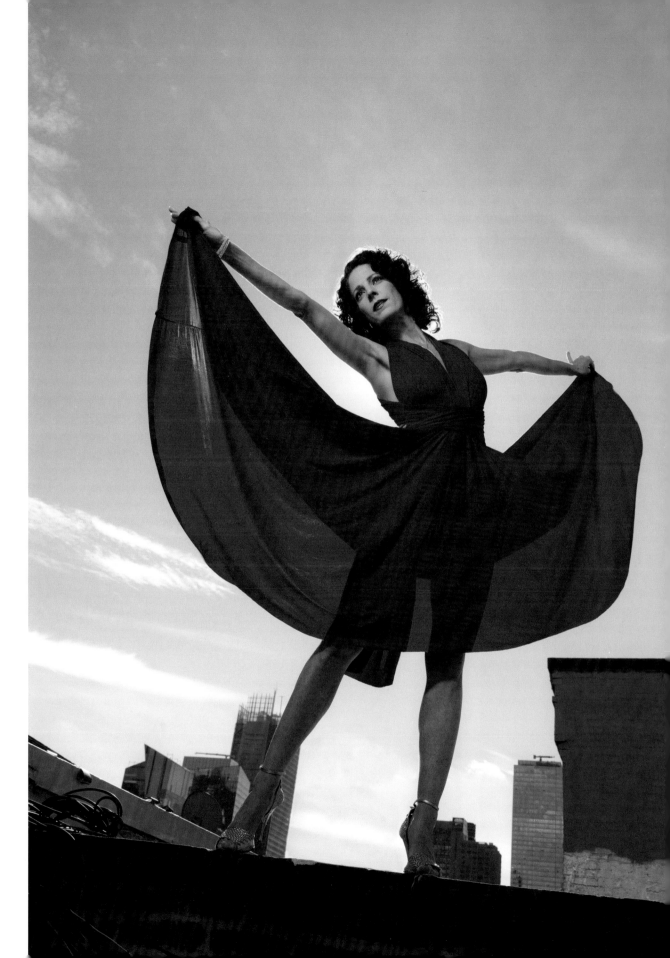

57. DECISIONS, DECISIONS, DECISIONS

A Spirited Subject

Jaleel King is a colorful character. What makes him unusual is his spirit and motivation. A shotgun blast by an angry neighbor left him paraplegic since the age of eight. He is mostly confined to a wheelchair, but his desire to be a photographer made him adapt—and his wheels are now a rolling studio, complete with a beauty dish on a movable boom arm. The battery for this AlienBees flash is mounted on the back of his wheelchair. This kind of determination and irrepressible spirit just has to earn respect. Visit www.jaleelking.com to learn more.

Capturing Their Character

When photographing someone, you have to consider the treatment on numerous levels. Composition—wild, crazy angles or more straightforward? How are you going to frame them? Lighting—dramatic or more traditional? What will the background and setting be? All of these things need to be balanced. Sometimes, the decisions are made beforehand; other times, the right choices flow out of the selected location.

> **TECH SPECS:**
> 1/160 second, f/5.6, 400 ISO
> Canon 6D
> Canon 24–70mm f/2.8 II
> Profoto flash with 1x3-foot gridded softbox

Location Selection

When I contacted Jaleel about photographing him and his wheels, he suggested the incredibly surreal Magic Gardens in Philadelphia. The crazy colors and patterns in this locations are a bit of a visual overload, so I decided to play it quite straight with these portraits. Amidst the shifting patterns that don't allow your eyes a place to rest, your attention naturally goes to our subject. Repetitive patterns usually create simplicity in a composition; here, we had a visual mess, and yet that is what helps draw your attention to Jaleel.

Lens and Lighting

I chose a longer lens to compress the perspective and placed Jaleel in front of a tall mural that provided enough space to include his beauty dish (which I fired, too) in the frame.

The lighting was fairly simple as well. I placed a gridded 1x3-foot softbox as the main light on Jaleel and his wheelchair-mounted lighting setup. I added a second light with a 10 degree grid on a reflector for a gentle spotlight on him.

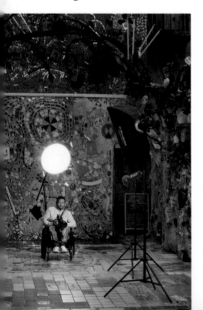

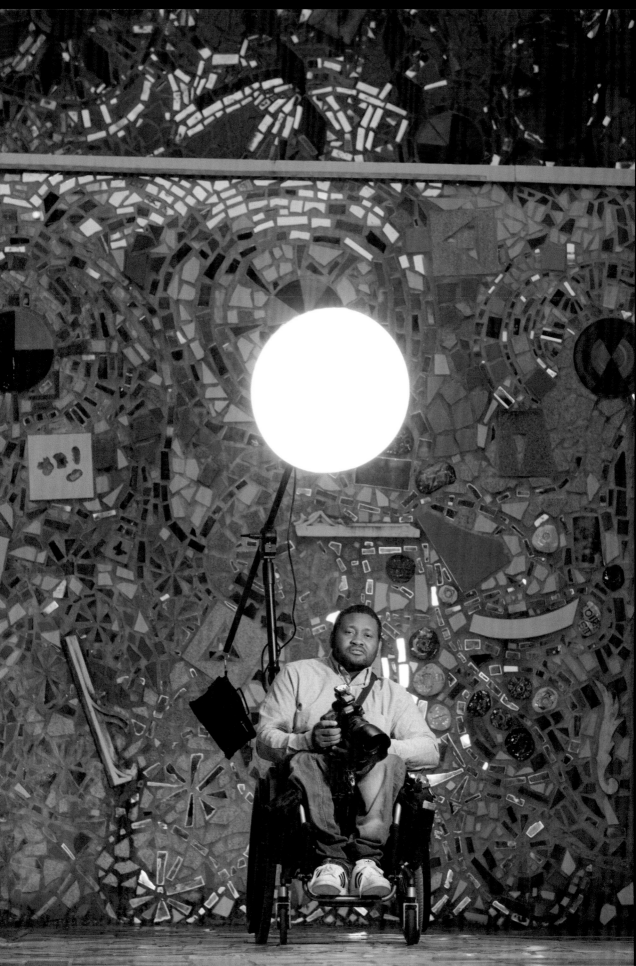

58. COSPLAY PORTRAIT

*A*rtist Ger Tysk creates fantastic outfits and has published a book on cosplay. For this portrait, Ger dressed as Sayaka Miki, a magical girl from Puella Magi Madoka Magica who uses her sword to protect people from evil.

Location

To complement the anime/comic-book boldness of her character and dress, we went to the 5 Pointz, a building that was covered with graffiti art from end to end. Shortly after our session, the building was white-washed to some bland color, so I am glad we were able to use it as a backdrop. Even if in a small way, these photographs are a record of the place.

Lighting

Since anime has a specific flat look, it wouldn't have made sense to light this portrait with the moodiness of, say, a Marvel comic-book character. It needed fairly even lighting.

The main light was a 3x4-foot Profoto softbox for soft light on Ger. A 1x3-foot gridded Profoto softbox was added behind her as a rim-

This retained the TTL exposure, but as a fixed manual setting that wouldn't change as the pose or composition was altered.

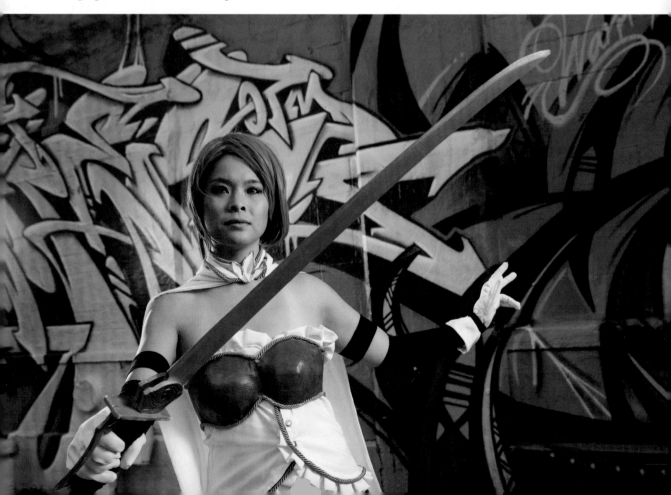

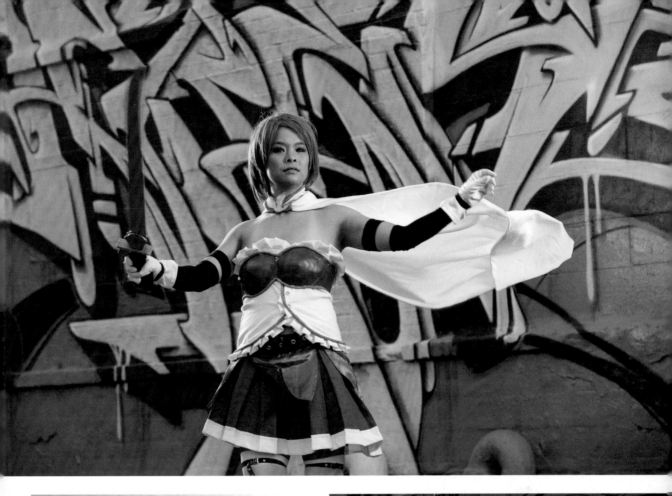

TECH SPECS:

1/180 second, f/5.6, 100 ISO
Canon 6D
24–70mm f/2.8 II
Profoto B1 flashes with softboxes

light and to put a little bit of light on the wall in the background. To control (and even minimize) the amount of light falling on the wall, I feathered the main light away from the wall.

The lights were two Profoto B1 units set to manual. In made an initial exposure via TTL mode; when I checked and saw the test exposure looked good, I flipped to manual exposure mode via the Air Remote TTL controller. This retained the TTL exposure, but as a fixed manual setting that wouldn't change as the pose or composition was altered.

Of all the incredible graffiti that adorned the 5 Pointz Building, I felt that this section best fit the styling of Ger's character. It is dynamic and has no cartoon faces or figures behind her to distract attention.

59. **STEAMPUNK/FUTURIST PORTRAIT**

*T*erri Claire's story is about empowerment; her tattoos, dress, and personal style are an affirmation of her independence. Terri is a teacher, holding a degree from Columbia University. With numerous tattoos, a daring style of dress that borrows from cosplay, steampunk, and futurist themes, she hopes her work as a model will help to erase negative stereotypes about women with tattoos.

Location and Composition

With all that in mind, we had to think of a location that would be complementary. I didn't want the images to become too much about the location itself. I just wanted the scene to enhance my portraits of Terri.

Meeting up in a cemetery, I looked for a background that would provide a sense of where we were, but not be immediately recognizable as

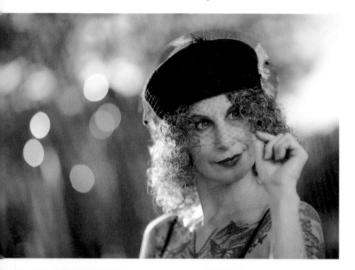

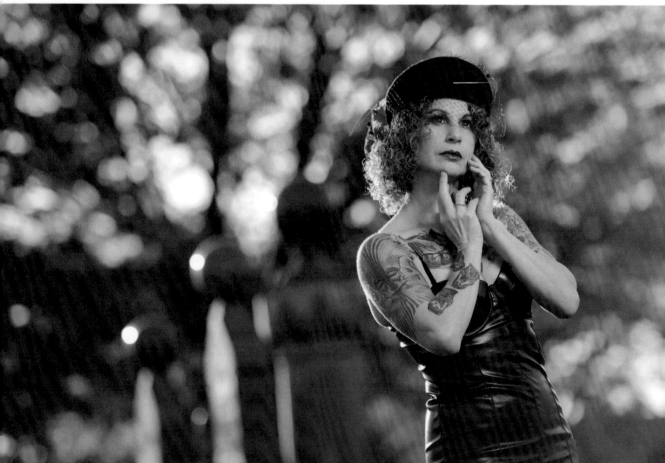

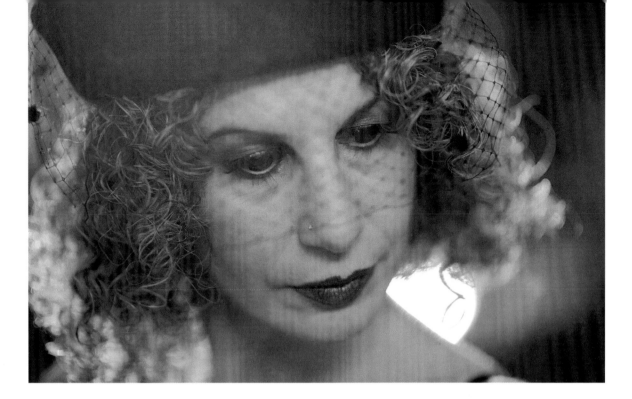

a cemetery. I didn't want to have Terri pose with headstones or anything so blatantly associated with the location.

Roaming around, I noticed a series of tall monuments—like a row of chess figures. From a certain angle, they were staggered in the background. I decided to have Terri pose in front of them. This repetition in the background brought a certain simplicity to the composition.

I positioned myself at an angle that let me include a tree (with some late fall colors) in the frame. From the "other" side, I would have had just a blank sky in the background. I liked the way the out-of-focus tree helped fill the frame. Shooting with the 70–200mm compressed the perspective and allowed me to be more selective about what I included in the final photograph.

Lighting and Exposure

The light on Terri was from a Profoto 600R with a 1x3-foot gridded softbox. The images on the facing page were shot at f/2.8 with a 70–200mm lens. For the image above, I wanted

a shallower depth of field, so I switched to my 85mm f/1.4 lens and shot wide open. I added a neutral density filter to cut the ambient and flash light, so the shutter speed and ISO setting remained unchanged.

TECH SPECS (FACING PAGE):

1/250 second, f/2.8, 50 ISO
Nikon D4
Nikon 70–200mm f/2.8 VR II
Profoto 600R with gridded 1x3-foot softbox

TECH SPECS (ABOVE):

1/250 second, f/1.4, 50 ISO
Nikon D4
Nikon 85mm f/1.4G AF-S
Profoto 600R with gridded 1x3-foot softbox
B+W 77mm 0.9 (3 stop) ND filter

60. DEPTH OF FIELD CONTROL

Flash Sync Speed and Aperture

When working with larger flash units and studio-type flash units out on location, you're limited to your camera's maximum flash sync speed. If you go over it, you'll get that black band across part of your frame. That ceiling in shutter speed choice also limits your choice of aperture when shooting in bright light.

For this series of photos of Sean Nowell, a New York–based saxophonist, we shot on the Brooklyn waterfront to get the New York skyline in the background. At $^1/_{250}$ second (the maximum flash sync speed of the Nikon D4), the resultant aperture was f/8 for the light of the day. I added light from a softbox to balance the exposure for my subject against that of the city.

A Better Choice

While shooting at f/8 didn't look so bad (*left*), the background just really melted away at f/2.8 with a long focal length (*below*).

TECH SPECS:

1/250 second, f/2.8, 100 ISO
Nikon D4
Nikon 70–200mm f/2.8
Profoto 6009R flash with softbox
B+W 77mm 0.9 (3 stop) ND filter

◀▼ The image shot at f/8 (*left*) and f/2.8 (*below*).

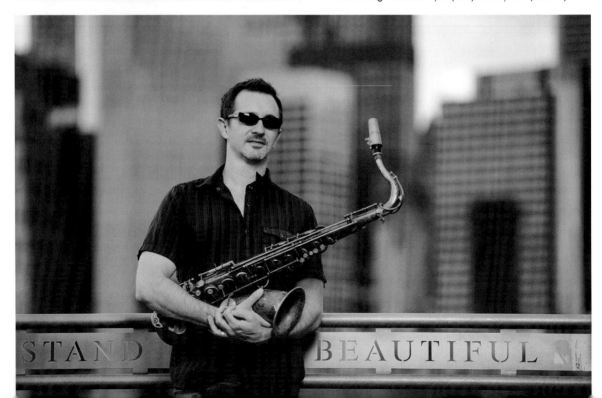

To pull the exposure down to the point where f/2.8 was a useful and usable aperture, I added a 3-stop neutral density filter. (You can get ND filters in an entire range of strengths.) Adding

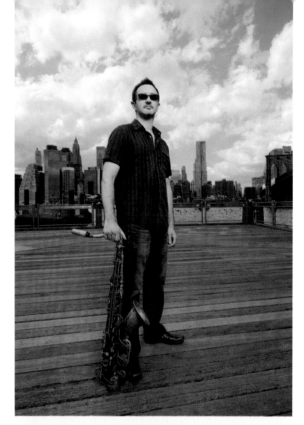

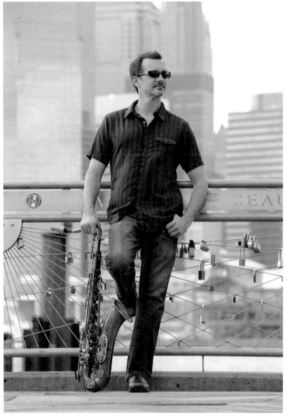

Perspective Matters

This image was shot at f/14—but the massive amount of depth of field didn't detract from the image. Sean remained dominant in the frame due to the perspective.

this filter meant 3 stops less ambient light and 3 stops less flash. However, the loss in flash exposure didn't concern me, since the *balance* between the flash and ambient exposure remained. What mattered was that f/2.8 goodness!

Location

I really liked this spot with the words "stand" and "beautiful" (part of a Walt Whitman poem about Brooklyn) visible on the railing. It just seemed appropriate for a musician's portrait—stand beautiful.

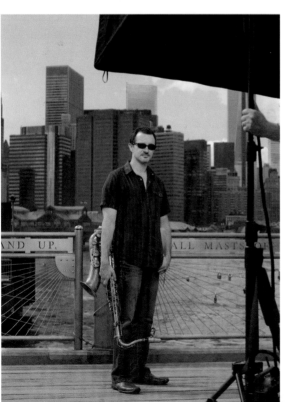

◄ *(top)* The scene with just the available light.

◄ *(bottom)* A pull-back shot showing the softbox in position.

INDEX